EDIN

D0263686

INTERMEDIATE 2 & HIGHER

Art and Design

grade **booster**

 Paul Cassidy & Alistair Cormack

Text © 2011 Paul Cassidy and Alistair Cormack
Design and layout © 2011 Leckie & Leckie
Cover image © Thinkstock Images

01/240811

ISBN 978-1-84372-740-8

Published by
Leckie & Leckie
an imprint of HarperCollins*Publishers*
Westerhill Road, Bishopbriggs, Glasgow, G64 2QT
T: 0870 460 7662 F: 0870 787 1720
E-mail: enquiries@leckieandleckie.co.uk
Web: www.leckieandleckie.co.uk

FOR KEVIN

Special thanks to
Roda Morrison (copy-editing),
Helen Bleck (proofreading),
Virginie Renard (proofreading),
Planman Technologies India Pvt (page-layout).

A CIP Catalogue record for this book is available from the British Library.

CONTENTS

1 Introduction

WHO IS THIS BOOK AIMED AT?

This book is designed for everyone studying Intermediate 2 Art and Design and Higher Art and Design. It is full of tips and practical advice on how to improve your exam answers. The book focuses on the written exam part of your course, the Art and Design Studies exam (Art and Design Paper 2). The book is split into two parts: Intermediate 2 and Higher. In each part there are sections giving you advice on how to write your answers for the exam, and also tips on exam revision and preparation.

WHAT WILL THIS BOOK HELP ME TO DO?

As it says in the title, this book is designed to **boost your grade!** In particular, the book will help you to prepare for the written exam. There are lots of examples of good answers – and weaker ones, too. By looking closely at these examples you will learn what makes a good answer.

HOW SHOULD I USE THIS BOOK?

The book is split into two parts: Intermediate 2 and Higher. It is not meant to be read all at once. Use it when you are revising or answering practice exam questions. Dip in and out of it – you might find some parts more relevant to you than others.

DOES THIS BOOK CONTAIN ALL THE FACTS I NEED TO LEARN FOR THE EXAM?

No! Your teacher will tell you how to find out the facts and background information you need to know about your artists and designers. This book will help you to turn that knowledge into successful exam answers.

2 Intermediate 2 and Higher Art and Design Course Structure

- *The Practical Folio*
- *Art and Design Studies*
- *Paper 2 (the written exam)*

THE PRACTICAL FOLIO

The Practical Folio provides you with an opportunity to demonstrate your artistic skills, develop your design skills and promote your creative thinking.

The folio is made up of two units:

- Expressive unit
- Design unit

An equal amount of time should be spent on each of these parts. Both parts are worth 80 marks each.

Expressive Unit

In this unit you should select **one** area of study from the following:

- Still Life
- Portraiture
- Figure Composition
- Built Environment
- Fantasy and Imagination

In this part of the course, **good drawing** and **media handling** skills are being assessed and your work should relate to a chosen theme.

Picture-making skills are also a very important part of this unit, where you can explore a personal theme through compositions and a variety of media approaches.

You should select an area of study which you find stimulating and interesting, e.g. landscape, still life, portrait or figure composition. A good approach may be to link your practical work to your Art Studies and look at artists who have worked in that area. Remember, a theme should be developed and explored within your chosen area of study.

There are three parts to the Expressive unit:

- Investigation
- Development
- Final outcome

Investigation

The first sheet of A2 should contain a series of detailed analytical drawings and colour studies, including some from first-hand sources, e.g. drawings of real objects or models, which relate to your theme and area of study.

 There is no set number of drawings required but a good guide would be approximately eight to ten quality pieces of work. Remember, it is quality not quantity that is being assessed.

In your investigation you should demonstrate a good understanding and awareness of the visual elements, i.e. line, shape, colour, tone and texture. You should include at least two pieces of work in different media and it is advisable to produce at least one in colour. If you are making drawings from photographs, it is best practice to take the photos yourself as part of your investgations.

 Choose appropriate media for the subject matter you are studying, e.g. large tonal studies may be best suited to charcoal or paint whereas smaller delicate line drawings may suit pencil or pen and ink. It is a good idea to attempt two or three versions of the subject before selecting pieces for presentation or assessment. This selection should be your best quality work.

This part of the course is worth **20 marks.**

Development

This is the picture-making stage of the unit, where you explore compositions and ideas using your drawings and colour studies from the investigation. There should be at least **two ideas** explored at this stage, one of which will be

refined and taken further towards a final composition. Select your drawings for development carefully.

Consider the subject matter in the drawings. Try out several compositions exploring the use of media, colour and scale. Other visual elements should be considered at this stage as well. Try to experiment with different arrangements of the objects in the picture and consider different viewpoints, e.g. a close-up, cropped-in viewpoint or a wider viewpoint to incorporate more of a setting or a background.

There is no set number of pieces of work to submit on the development sheet, but at least four images should be included.

If you are working with three-dimensional media, you should include ideas in a series of drawings and sketches. Three-dimensional maquettes (models) should also be included in the development.

Consider the following points when creating three-dimensional pieces:

- form
- shape
- texture
- line
- scale
- use of materials

Photographs of your development may also be included.

One of the two ideas in your development should be refined and taken towards a final outcome.

This part of the course is worth **20 marks.**

Final outcome

This is a single piece of work which could be a

- drawing
- painting
- sculpture
- print
- photograph
- mixed media piece.

There should be a clear link between the final outcome and the previous two stages of the project. The final outcome must be of high quality. Adjustments can be made to your idea to allow for the difference in scale, e.g. you may need to extend the background areas or adjust the composition.

Presentation of your expressive work is very important. Lay out the work in a manner that allows the marker to understand the unit clearly through the investigation and development, to the final outcome.

When mounting your work for assessment, avoid putting images on top of each other (layering). Each image should have its own space on the sheet.

There are **40 marks** allocated to the final outcome, so allow yourself plenty of time to do this. It should not be rushed.

Design Unit

In this unit you should select **one** area of study from the following:

- Graphic Design
- Product Design
- Textile/Fashion Design
- Interior Design
- Jewellery Design
- Environmental/Architecture Design

You should identify a design problem in one of these areas and investigate a **design brief** with the help of your teacher.

The design brief should be developed fully to produce a solution.

Design skills and creative thinking, including the use of technology, should all be part of a good folio.

A good design folio will have a clearly constructed design brief from **one** of the areas mentioned above.

Design brief

A good design brief is essential to getting started. Talk to your teacher and take advice.

The brief should be stimulating and allow you to develop design ideas in a creative way.

Choose an area of design you are comfortable with and which interests you. You will have to investigate this area thoroughly.

 It is a good idea to build on previous learning and acquired skills. This will help you approach the design project with confidence.

The design folio has three main parts and an evaluation. The three main parts are:

- Investigation/research
- Development of ideas
- Design solution

Investigation/Research

You must research every aspect of the design brief. You can do this by using photographs, diagrams, sketches, detailed drawings and include samples of materials where appropriate. Use this research to inspire and help you develop your own ideas.

There must be examples of existing designs by other designers in this investigation sheet.

 Be very selective of the images and materials that you include on the investigation sheet. Do not clutter with irrelevant images.

The investigation is worth **24 marks**.

Development of ideas

A minimum of two ideas should be developed and refined.

These ideas are based on your reference materials and should explore every aspect of the brief, e.g.

- aesthetics
- function
- target audience
- use of materials.

One of these ideas should be taken further towards a final **design solution.**

The development of ideas is worth **24 marks.**

 Adding notes to drawings or ideas is a good way of explaining your thinking to the marker. Keep them short, but show the marker how your ideas have progressed.

Design Solution

There should be clear links between the design brief and the design solution.

The design solution is the final part of the Design unit. It should be:

* a quality product in either 2D or 3D
* presented in context, e.g. a piece of jewellery should be shown on a model or mannequin

 There should be clear links between the design brief and the design solution.

Evaluation form

This form is **very important.** It is attached to your investigation sheet.

It outlines your design brief and tells the examiner what you intend to do. You should identify on this form the strengths in your design activity and any weaknesses. Discuss this with your teacher before completing and attaching the form.

The evaluation is worth **8 marks.**

 Take your time when doing the evaluation form. Try a practice copy. Presentation of the unit is very important. Lay out the research and development work clearly, as this explains the design process.

ART AND DESIGN STUDIES

The purpose of the Art and Design Studies Unit is for you to develop a greater understanding and awareness of the work of artists and designers. You should look at their work in depth, their influences, methods of working and contribution to the visual arts and design. You should be able to comment and offer opinions on artists' and designers' work in a critical and informed manner, using appropriate artistic language.

Art Studies

The Art Studies part of the course should support the practical work in your Expressive Unit. When you are studying these artists you will get an insight into their working methods, influences and sources of inspiration. The study should influence how you handle materials and the themes you explore. If you are working on a still life project, then it would be good practice to look at artists who worked in this genre, e.g. Jack Knox, Elizabeth Blackadder and Paul Cézanne. A similar approach should be taken if you are working in landscape or portraiture, etc.

Design Studies

The Design Studies part of the course should support your practical work in the Design unit. When you are studying these designers you will get an insight into their working methods, use of materials, influences and sources of inspiration. The study should influence how you approach your design brief, the materials you use and the themes you explore. If you are working on a graphic design, then it would be good practice to look at designers who worked in this area, e.g. Alphonse Mucha, David Gentleman and A.M. Cassandre. A similar approach should be taken to product design, textile/fashion design, etc.

Art and Design Studies: the Summary

A summary should be completed for the visual arts and another one for design. Both of these should be approximately **500 words**. The key points in the art and design studies summary should be:

- Some background information on the artist's/designer's life – where they lived and worked.
- Historical contexts should be included – what era did they work in?
- Discuss whether they were associated with any major style or movement – Impressionists, Glasgow Boys?

- For designers, were they associated with a particular style or movement, e.g. Art Nouveau, Art Deco?
- Their working methods.
- Their main source of inspiration.
- Discuss examples of the artist's/designer's work.
- Compare each artist's/designer's work, e.g. similarities, differences in their approach.
- You should include personal opinions and make informed judgements on their work.
- Remember that the artists/designers that you have chosen to study should be from the era 1750 to the present day. One of them should be contemporary (from the last 25 years).

 Producing a good Art and Design summary is also good preparation for the written exam.

PAPER 2 (THE WRITTEN EXAM)

Let's start with the basics.

The written exam is split into two parts: Art studies and Design studies.

You **must** answer one question from both parts.

Each question covers a different type (genre) of art or design.

In **Art Studies:**

Question 1 is always about **Portraiture**.
Question 2 is always about **Figure Composition**.
Question 3 is always about **Still Life**.
Question 4 is always about the **Natural Environment**.
Question 5 is always about the **Built Environment**.
Question 6 is always about **Fantasy and Imagination**.

In **Design Studies:**

Question 7 is always about **Graphic Design**.
Question 8 is always about **Product Design**.
Question 9 is always about **Interior Design**.
Question 10 is always about **Environmental/Architectural Design**.
Question 11 is always about **Jewellery Design**.
Question 12 is always about **Textile/Fashion Design**.

You will already know which two questions you are going to answer before you sit the exam as they will relate to your practical folio of art and design work. Your teacher will have helped you research artists and designers and you should be clear which two questions their work covers.

 The most important piece of advice on how you can boost your grade is to remember only to answer **one** question from Design Studies and **one** question from Art Studies.

Each question is split into two parts: **(a)** and **(b)** – you must answer both parts.

Part **(a)** of your question will relate to the picture on the page. It may be something you have seen before, but usually it is an image you are not familiar with. Part **(a)** of the question is for you to demonstrate your critical skills and to express your opinion. Part **(b)** of the question is for you to demonstrate what you remember about famous artists or designers, with an emphasis on their work.

Websites

Try the SQA's website www.sqa.org to access past papers with markers' notes.

Your school or college may have access to SCRAN, where images in the art and design section split into the 12 exam question categories. Your school/centre should be able to give you the username and password if needed. You can also access SCRAN from public libraries using a library card. The website is http://www.scran.ac.uk.

Intermediate 2 Art and Design Paper 2

- *Section 1: Art Studies*
- *How to answer questions in Section 1: Art Studies*
- *Section 2: Design Studies*
- *How to answer questions in Section 2: Design Studies*
- *Intermediate 2 exam preparation*

INTRODUCTION

There are two sections to this question paper.

Section 1: Art Studies and Section 2: Design Studies.

Each section is worth 20 marks.

SECTION 1: ART STUDIES

This section consists of six questions covering the six areas of visual arts:

- Question 1: Portraiture
- Question 2: Figure Composition
- Question 3: Still Life
- Question 4: Natural Environment
- Question 5: Built Environment
- Question 6: Fantasy and Imagination

There are two parts to each question: **part (a)** and **part (b)**.

The **(a)** question will test your ability to respond to an image of work from the visual arts, discuss the artist's use of visual elements, composition, etc.

 Be aware that part **(a)** questions may not always include the image of a painting. It could be a piece of sculpture, a drawing, a collage or a mixed media piece. It may be something unfamiliar to you, but work through the question as you would do with work that is familiar to you. Don't panic.

The **(b)** question will test your knowledge and understanding of the work of important artists, movements and styles from 1750 to the present day.

 You must answer a full question in section 1, e.g. if you choose Portraiture in section 1 you must do the **(a)** and the **(b)** questions for Portraiture. Do not attempt to answer more than one question.

In this book we will look at four of the six questions in Art Studies.

- Portraiture
- Figure Composition
- Still Life
- Natural Environment

HOW TO ANSWER QUESTIONS IN SECTION 1: ART STUDIES

 Some of the answer examples you will see in this book will appear to be awarded more than 10 marks. The marker will award a mark for each valid point the candidate makes. If there are more than 10 valid points then no extra marks will be awarded. Candidates often cover more points than is necessary to make sure that they will gain full marks.

Exam Example 1: Question 1 part (a) Portraiture

Here is a typical part **(a)** question on portraiture. This example focuses on **your opinion** and how successfully you feel the artist uses visual elements in the portrait. A key word in the question below is **character**. This refers to the personality of the sitter.

1. **Portraiture**

 (*a*) In your opinion how well does the artist use *colour*, *shape* and *composition* to show the character of the model?

 (SQA Int 2 Art and Design Past Paper, 2008)

A good answer will have well-justified personal opinions about the use of the visual elements of colour, shape and composition by the artist.

Here are two extracts from **two** very different answers.

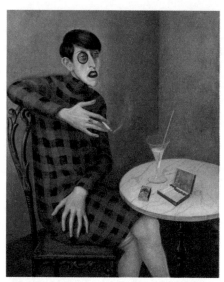

Portrait of the Journalist Sylvia von Harden (1926) by Otto. Dix, oil and tempera on wood (120 x 88 cm)

 The artist has used a lot of red in the painting and there are some patterns on the woman's dress. I think she looks tired, upset and uncomfortable. **(1 mark)** The composition is good as she is sitting next to the table smoking. The way she is sitting tells you she might be angry or something and she looks quite strange. **(1 mark)**

This is a weak response because the opinions are not justified. This answer obviously would not achieve full marks.

The candidate merely states that the artist has used a lot of red. This does not convey the importance of this colour in relation to the character, which is what the question is about.

Stating that the composition is good because she is sitting next to the table is very basic and doesn't really explain the importance or any understanding of how the artist has placed the figure in the painting. The main point is that you must justify statements to show you really do understand the question and the visual elements.

The following is an extract from a stronger answer which does justify opinions and gives a more detailed answer to the question.

 The artist Otto Dix uses colour, shape and composition to show the character of his model in the painting. **(1 mark)** He uses the medium of oil and tempera paint to create a smooth, all-over finish. **(1 mark)** Red is used to create a feeling of anger or the less pleasant side of life and gives you the impression that the subject being painted is passionate and fiery. **(1 mark)**

There are various deep reds to show emotion and suggest that the subject is thoughtful and sensitive. **(1 mark)** The shape of the subject makes her look quite masculine and forceful. **(1 mark)** Her hands are composed with widespread fingers in a masculine fashion but her legs are crossed to give an air of femininity. **(1 mark)**

The woman is sitting sideways on a chair, again giving a feeling of masculinity. She is smoking a cigarette from a large packet on the table and a martini glass is also on the table, suggesting she enjoys the darker side of life because she smokes and drinks. **(1 mark)**

She has a grimacing look on her face, suggesting that she is annoyed, unhappy or emotional, which goes along with the use of deep passionate reds. **(1 mark)**

The shapes of the objects in the picture create a feeling of masculinity and harshness while the colour communicates ideas of passion. **(1 mark)**

In my opinion I think the artist Otto Dix uses shape, colour and composition really well to show the character of his model. **(1 mark)**

This is a very good answer to the question, with each point well justified and clearly stated. This would achieve the full 10 marks.

There are some personal observations about the sitter being masculine and how the artist has depicted this. There is a good connection between colour and emotion referring to a *'feeling of anger'*. Another good connection made between the use of the colour red and the subject's expression: *'She has a grimacing look on her face'*.

The answer also mentions the visual elements, i.e. the shape of the woman's body, the positioning of her hands, her position in relation to the table and how these all contribute to the composition of the painting and the character of the person depicted.

There are 10 marks awarded for a good answer, so make 10 good, clear points.

Exam Example 2: Question 1 part (b) Portraiture

Preparation is very important for this question. Prepare well by memorising your artists and examples of their work. As in question **(a)**, 10 marks will be awarded, so once again make sure you have 10 good points in your answer.

A good answer to a **(b)** question should deal with aspects of portraiture such as likeness, personality, mood and expression from a personal point of view.

Below is an outline of how to structure your answer to a part **(b)** question on portraiture.

The first part of your answer should deal with brief background information on the artists you will be referring to and the type of work they produced. At this stage you may refer to a movement or style they were associated with.

The second part of your answer will deal with examples of the artists' work; depending on the wording of the question, you may be asked to compare the work of two artists who produced portraits or discuss two specific examples of work from two artists. You must comment on the artists' style, approach and working methods and refer to the paintings by their titles.

This is an opportunity for you to demonstrate your knowledge and understanding of the artists and their work. Also, you may be asked to compare and contrast their styles, e.g. are there any major similarities or differences? Remember, you must justify your comments.

Here is a typical example of a **(b)** question in portraiture along with a good answer showing where the marks have been awarded.

1. **Portraiture**

 (*b*) Compare and contrast **two** portraits by any **two** artists. Comment on the different approaches and methods used by the artists.

 (SQA Int 2 Art and Design Past Paper, 2007)

 Pablo Picasso was born in 1881 and belonged to the art movement Cubism, which consists of fragmenting 3D forms into flat areas of pattern and colour overlapping and intertwining. (**1 mark. This displays some knowledge of the artist and the movement he was associated with. It refers to an aspect of the Cubist style.**)

Peter Howson, a contemporary artist, was born in 1958 and was associated with a group of artists known as the New Glasgow Boys. His work consisted of paintings which included bold draughtsmanship, distortion of figures, strong composition and the ability to portray the extremes of gloom. (**1 mark. This is good simple information about the artist. It gives a flavour of the type of work he produced, referring to composition and mood.**)

The next part of the answer deals directly with examples of the artists' work.

A portrait by Pablo Picasso is 'Portrait of Dora Maar seated' (1937), which includes the image of a woman made out of various shapes and colours. (**1 mark**) In this

portrait Picasso uses shape in a very strong way to clearly define the outline of the woman. **(1 mark)** His use of colour is dull, flat and basic. However, it still catches your attention as the details added by the shades are so fascinating. **(1 mark)** The tone of each area of the portrait draws your attention immediately as it contrasts so much from dark to light; however, it gives an original feeling to the portrait. **(1 mark)** Line is used to add detail to the portrait and to help you to understand the image Picasso was trying to create. **(1 mark)**

These statements describing the painting are very good because they illustrate detailed knowledge of the work and a good understanding of how visual elements play an important part in this work.

This next part of the answer deals with Peter Howson and an example of his work. This is similar in structure to the part about Pablo Picasso.

A portrait by Peter Howson is 'Steven Berkoff' 2002, which includes a large image of a man with a block of flats in the background. **(1 mark)** The use of colour in this portrait is very restricted and not varied, almost monochromatic. **(1 mark)** The colours used are very dull and dark, giving the portrait a gloomy feeling and a dark atmosphere. **(1 mark)** The use of shape adds detail to the image of the man and is very bold and hard, and line is also used to help certain aspects of the portrait stand out. **(1 mark)**

Again, in this part of the answer, there is a good awareness of the visual elements and an understanding of the artist's work.

The final part of the answer concludes by highlighting the different approaches to portrait painting by these two artists.

These are good examples of portraiture as they are so different from each other. Even though they use the same techniques to create images, one approach is quite abstract (Picasso) and the other, although slightly exaggerated, is more realistic (Howson). **(1 mark)** It shows how approach and different techniques can be used in such a way as to completely change the atmosphere and mood of the painting. **(1 mark)**

This is an excellent answer and would be awarded full marks. There are at least 10 good points made and there is a very good understanding of the artists' work, and their use of visual elements.

When you are writing your Art Studies summary make sure you are familiar with at least two of the artists' works by title and how they were created. You should be able to identify the key visual elements in each of these paintings and explain the importance of them.

Exam Example 3: Question 2 part (a) Figure Composition

In this type of question, you are asked mainly about the artist's use of visual elements and the visual impact of the work. You are also asked to justify your reasons for the comments you make. If you refer to each of the visual elements in the question **and** justify their contribution to the image, you will gain marks.

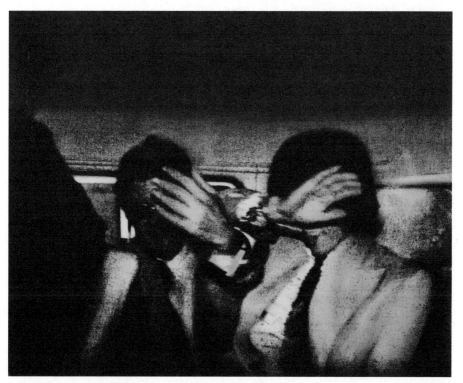

Swinging London 67 (1968–69) by Richard Hamilton, Silkscreen ink on Synthetic Polymer paint on canvas (67.3 x 85.1 cm)

2. Figure Composition

(a) How well does the artist use *colour, tone* and *shape* to give this figure composition visual impact? Give your opinion.

(SQA Int 2 Art and Design Past Paper, 2007)

In your answer to this question you should comment on the following:

- Shape – refer to the obvious framing of the figures by the car windows, and the raising of the hands.
- Colour – link colour and tone to create the flash effect. Although there is limited use of colour, the image has small passages of warm colours, which contrast with the cool greys and greens.
- Tone – there are strong contrasts of tone in the face of the man on the left which increases the dramatic effect, but there are also subtle tones in the centre of the picture around his hand and the hand of the woman sitting next to him.

> **!** Remember, it is your opinion of this painting you are asked for and as long as you can justify your comments when discussing the visual elements you will be rewarded with marks.

> **!** Try to imagine the size of the work from the information provided, in this case 67 x 85 cm. This is a small painting.

Here is a good answer to the original question.

 The image displayed in the painting looks slightly blurred. The picture appears to be of two figures through a rectangular shaped window, a bus or a car window perhaps. **(1 mark)** The figures are holding up their hands to cover their faces. They seem to be hiding from something on the other side of the window. **(1 mark)** The mood and the atmosphere are hesitant and uneasy. The artist has cleverly used dull and dark colours to emphasise what seems to be an uncomfortable or unpleasant time. **(1 mark)**

The two hands in the painting, covering the faces of the two figures, seem to be highlighted. They are painted with bright, light colours. **(1 mark)** The fact that the figures are covering up is a main focus, emphasised by the central positioning of the hands. **(1 mark)**

The two figures are smartly dressed in suits, ties and shirts, suggesting they are going to, or have been at a formal event. Perhaps they are celebrities who do not want to be photographed. **(1 mark)**

The artist has achieved a smooth texture with the use of oil paint and silk screen on canvas which contrasts with the intensity of the situation. **(1 mark)** The colours grey, black and green, which are part of a neutral palette, seem to connect with the intense mood and atmosphere in the painting. **(1 mark)**

This painting is from a period in time (the 1960s) where there was an attempt to display social and political issues in paintings. **(1 mark)** Together with shapes, colours and textures in this painting great impact is created. I think this is a very successful painting. **(1 mark)**

This is a well-structured response, which clearly refers to the artist's use of visual elements and the visual impact of the composition. Reference is also made to the use of media 'oil paint and silk screen', and how this technique contributes to the success of the overall image.

Exam Example 4: Question 2 part (b) Figure Composition

In these questions you are expected to demonstrate knowledge and understanding of selected aspects of the visual arts. You should also be able to give your personal opinions and make judgements about artists' works – and you should be able to justify these opinions.

In this type of question you will be asked about figure compositions, which you should have looked at in your Art Studies.

A good answer will refer to the artist's work, their approach and choice of media (oil paints, watercolours, etc.). When discussing artists' work, you should also refer to their chosen subject matter, i.e. what is in their paintings, and reference should also be made to their use of visual elements (colour, tone, texture and brushwork, etc.).

When answering a part **(b)** question on figure composition, you should know:

- titles of the paintings
- when the artist produced the work – artist's early work or late work
- what the artist is trying to depict in the painting. What is the story?
- what are the strong visual elements in the painting that you can discuss in detail, e.g. light and shade, colour, tone and texture
- what the style of the painting is. Are the figures realistic, semi-realistic or abstract?

 It is good practice to make sure you know at least two paintings or works of art by each artist. This will give you a choice of work to discuss in your answer.

> When comparing artists' approaches to figure compositions, refer to the artists' use of visual elements and the style of the paintings, e.g *'Picasso has exaggerated the shapes and forms of the figures, whereas Renoir has treated the figures more realistically and naturally ...'* This style of comparing one artist to another in the same sentence is highly effective.

You will be asked your opinion on how successful two figure compositions are. Remember that, to gain marks, you must justify opinions by discussing the paintings in detail. The final part of the question is a comparison of each artist's approach to figure composition. You must discuss any similarities in their work, e.g. style, subject matter, use of media, etc., and then compare the differences.

Here is an example of a **(b)** question. It is accompanied by an excellent answer, which would gain full marks.

2. Figure Composition

(*b*) Discuss **two** figure compositions by any **two** artists. Explain why, in your opinion, they are successful. Refer to each artist's approach to figure composition.

(SQA Int 2 Art and Design Past Paper, 2007)

I have studied work by two great artists, Paul Cézanne and Pablo Picasso. Both worked on figure compositions but had unique styles. **(1 mark)** An example of a figure composition by Cézanne is 'The Large Bathers'. Cézanne spent a number of years on the painting and completed it in 1906. **(1 mark)** The picture has over twelve figures in it, which are arranged into triangle shapes: a triangle of bathers in each bottom corner which creates one large triangle with the branches of trees enclosing the whole picture. **(1 mark)**

The main colours of the painting are shades of browns, beige and blues. **(1 mark)** The use of these colours creates a horizontal striped pattern. In the foreground is the sandy ground with light shades of beige. **(1 mark)** There is a river running straight through the picture, which has shades of blue. There are more beiges and browns again on the opposite bank, and finally the colour changes to blue again to illustrate the sky. **(1 mark)** There are also strong highlights on the bathers to show the light.

Picasso also worked on a lot of figure compositions, especially through his 'Blue Period'. **(1 mark)** One example from 1903 is 'La Vie', which means life. This picture contains four figures in total. **(1 mark)** On the left are two semi nude lovers and on the right is a mother holding a baby; in the middle there are two portraits. **(1 mark)**

The painting symbolises birth, life and death, through the baby, the lovers and then the poor haunted people in the portraits. **(1 mark)**

Everyone's skin is very pale, which contrasts with the dark shadows created by light coming from the left. **(1 mark)** Overall, it is a much more depressing and darker picture than that of Cézanne, which is the one I prefer. **(1 mark)**

In this response there is a clear understanding and knowledge of the content of the paintings and there is a good description of the subject matter, particularly Cézanne's painting. The candidate has made more than the required 10 clear points and achieves full marks.

Reference is also made to the way the figures have been organised into groups (triangles). There is good understanding of the use of contrasting colours in the work, which depicts the mood of the painting.

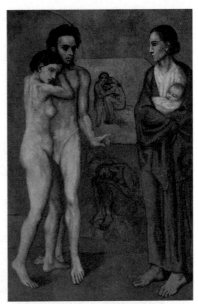

La Vie (1903) by Pablo Picasso, oil on canvas (239 x 170 cm)

In the second part of the answer, there is reference to images which symbolise birth, life and death. This shows a good understanding of the story being told in the picture.

Exam Example 5: Question 3 part (a) Still Life

In this section we will look at how to answer an **(a)** and **(b)** question on still life and how marks will be awarded.

The main points to note with regard to still life are:

- Subject matter – this refers to the content of the painting, the objects, etc., in the painting.
- Composition – this refers to how the objects have been arranged in a picture.
- Visual elements – this refers to tone, colour, pattern and shape.
- Style – this refers to the approach the artist has taken, realistic, semi-realistic or abstract.
- Technique/use of media – this refers to how the artist has produced the work, e.g. delicate use of water colours, bold painterly approach using oils or a mixed-media approach, e.g. collage, paint, pastels.

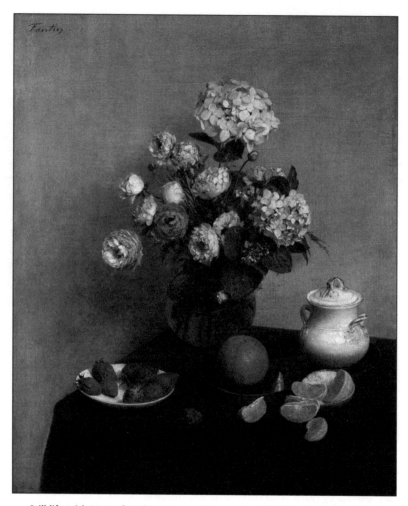

Still life with Vase of Hydrangeas and Ranunculus (1866) by Henri Fantin-Latour, oil on canvas (73 x 59.3 cm)

3. Still Life

(a) Describe the work. What is your opinion of the arrangement of the objects chosen by the artist? In your view how well does the artist use *tone*, *colour* and *painting technique* in this still life?

(SQA Int 2 Art and Design Past Paper, 2005)

This is a straightforward but reasonably challenging question where your knowledge and understanding of the visual elements, as well as an awareness of composition (arrangement of the objects), should be evident in your answer.

A full description of the still life, which is simple and traditional in subject matter, should be included in your answer. A good response would also refer to how well – and how very realistically – Latour has painted the flowers, fruit and objects in the painting.

 When asked your opinion on the arrangement of the objects, you may like or dislike it. Your opinion will be acceptable as long as you can justify it.

A rough guide to the allocation of the 10 marks available for this question would be as follows:

- Description of the work **3 marks**
- Arrangement of the objects **3 marks**
- Tone, colour and painting technique **4 marks**

Here is a short answer to the question. Suggestions for how this answer could be improved will follow.

 The artist uses tone well in the shadows of the flowers on the wall and on the inside of the vase. **(1 mark)** The tonal change on the spherical orange has been painted well; as it is a sphere the tone varies dramatically. I think Fantin-Latour has painted it very well and it looks realistic. **(1 mark)**

Latour's use of colours is good. The vivid colours of the orange and the strawberries make them stand out against the dull table and tray. **(1 mark)**

The dirty whites of the flower petals stand out against the dark green stems and contrast with the neutral tones in the background. **(1 mark)** Latour's painting is very good and he makes his paintings look very realistic, which I like. **(1 mark)**

I also like the fact that the brush strokes cannot be seen in this painting as it seems to be very smoothly painted. **(1 mark)**

This answer could be improved if there were more comment on the subject matter in the painting. There is no real description of other objects or reference to their arrangement, i.e. the composition. Marks would have been awarded if this had been mentioned.

Although tones are mentioned at the beginning, comments are limited to the shadows of the flowers on the wall and the inside of the vase. Further marks

could have been gained by mentioning the vast tonal range in the painting: from the cloth in particular, which is rich in tone, to the lighter tones of the flowers and lidded pot.

A good point, however, is made when referring to the use of tone in the orange, and its variation. The use of the term 'dirty whites of the flower petals' is also good because it gives an excellent description of the flowers in the painting.

Stating that the colours in the painting are good is not enough. Although the word 'vivid' is used, some comment on the contrast, the dark rich colours and the lighter brilliant colours which are affected by light, would increase the number of marks gained.

The brush strokes are mentioned at the end of the answer: they 'cannot be seen'. It would have been better to use a more descriptive term about the artist's painting technique, e.g. delicate brush strokes, subtle use of paint, or fine detailed brush strokes.

 Look through SQA past papers or on their website. You will see different examples of still life paintings and drawings used for question **(a)**. Some are traditional in nature, like the Fantin-Latour example. Other examples may be unfamiliar to you both in style and content, e.g. abstract still lifes, Cubist style or, in some cases, three-dimensional images. Make sure you are aware of the issues that relate to still life. These will help you answer any question, irrespective of the style of the still life.

Exam Example 6: Question 3 part (b) Still Life

3. Still Life

(b) Discuss and comment on **two** examples of still life by any **two** artists. Refer to style, use of media and composition.

(SQA Int 2 Art and Design Past Paper, 2007)

This is a typical part (b) question, where you are expected to demonstrate good knowledge and understanding of still life painting. You should be able to select two artists who painted still lifes and compare their contrasting styles, their working methods, and examples of their work.

You may also consider referring to the artists' use of media and whether their approach to still life painting was realistic, semi-realistic or abstract.

In the question you are asked to comment on two examples of still life by two artists. You must be familiar with the artists' work and be able to analyse and describe their work in detail. A very good answer will contain well-justified personal opinions and your preferences, i.e. which particular artist's work you like the most.

 Remember, the answer to this question should be based on the artists and movements you have studied in your Art Studies.

To help you structure your answer, it is best to break down the question by referring to the following points:

- titles of the paintings, including the dates they were produced
- discussion of the subject matter in detail, i.e. the objects in the painting
- a demonstration of your knowledge of the visual elements when you describe the artists' work, e.g. use of colour, tone, texture and line
- a reference to the styles of the paintings, discussing whether they are realistic, semi-realistic or abstract
- the choice of media used by the artists

The two artists' work you are discussing may contrast in style, subject matter and media handling. Do you have a particular preference? If you have, state your reasons clearly and justify them, e.g. 'I prefer Monet's approach to painting still lifes because of his use of colour and brush work. Morocco's still lifes are bolder and less realistic.'

Below is an excellent example of an answer to the question, which would be awarded full marks.

 I have chosen to study two artists, Claude Monet and Pablo Picasso. Both artists are from different movements and styles. Monet painted Impressionist paintings whereas Picasso painted in the Cubist style. **(1 mark)** Impressionist painters were obsessed with light and the way it affected surfaces such as water and skin. **(1 mark)** They were also interested in the way light creates shadows and they used complementary colours on objects and shadows. **(1 mark)**

Cubist painters were rather different, as they focused on geometric shapes with straight lines, which were almost box-like. Cubism could be compared to the Bauhaus as they were similar movements which were both interested in straight lines, geometric shapes and forms. **(1 mark)** These styles were both popular in the twentieth century, whereas Impressionism was popular in the nineteenth century. **(1 mark)** The two still life

paintings that I have studied from each artist are similar in content as they both focus on fruit. The painting 'Pears and Grapes' by Claude Monet 1880 is oil on canvas. **(1 mark)** The still life composition is fairly basic. It is a large group of objects in the centre of the canvas, which consists of grapes, pears and some sort of leaves. This is the focal point of the painting. In my opinion it looks like a fern. **(1 mark)** In the right-hand corner there are two pears, but I think they look like apples. The composition is quite simple but well balanced and looks good in my opinion. **(1 mark)**

I believe that the artist has painted in a style where the still life looks realistic but is not like a photograph. **(1 mark)** The colours the artist has used are quite dull, although there are traces of brighter colours throughout the painting. In my opinion the artist has used large, quickly placed brush strokes and blended the colours in well. **(1 mark)**

I also studied Pablo Picasso's still life painting 'Compotier, Fruit and Glass', which was painted in 1909 with oil on canvas. **(1 mark)** This still life contrasts with Monet's painting in many ways. Picasso's still life is much more complex than Monet's. **(1 mark)** It consists of two glass bowls, a glass and fruit. The two glass bowls contrast in height, which is interesting as one is placed lower down in the composition. **(1 mark)**

Both bowls are full of fruit and there is also fruit on the table, which looks like pears. Picasso's use of colour is bright but also contrasts with the background so that the main objects in the painting stand out in the composition. **(1 mark)**

Picasso has used colours such as blue, yellow and green to make the pieces of fruit more prominent. The style which I think Picasso has painted this picture

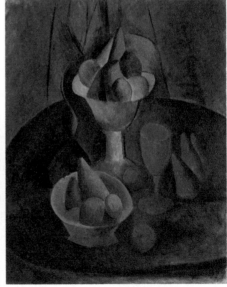

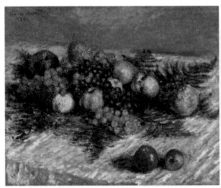

Still life with Pears and Grapes (1880) by Claude Monet, oil on canvas (65 x 80 cm)

Compotier, Fruit and Glass (1909) by Pablo Picasso, oil on canvas

in is deliberately exaggerated. The painting looks unrealistic. (1 mark) The brush strokes Picasso has used contrast with Monet's brush work as they look a lot smaller and more detailed. (1 mark)

I like both paintings and the styles of both artists. I like the way they contrast with each other but have similar objects in them. (1 mark)

I do prefer Picasso's still life as it is unrealistic, amusing and interesting to look at. I like the bold colours he has used, which contrast with the duller background colours. (1 mark)

The introduction to the answer is very good. Knowledge and understanding of Monet and Picasso's work is shown by discussion of the artists' style and approach to painting. There is also reference to the movements they were associated with, i.e. Impressionism and Cubism. Bauhaus style is also mentioned in the answer. This shows an awareness of other styles which were prominent at the time.

In the next section of the answer, the candidate gives a good description of the two still lifes by the artists and how they used the visual elements, particularly colour.

Picasso's approach to painting is compared with Monet's. The candidate demonstrates a sound knowledge of these particular still lifes. They are good descriptions. Reference is made to the artists' use of colour and the 'unrealistic' and 'realistic' style of each painting.

The answer concludes with an opinion on these artists' work and states a preference, in this case Picasso. The opinions are well justified.

Exam Example 7: Question 4 part (a) Natural Environment (Landscape)

When answering this type of question, refer to the following points:

- Outline the method used by the artist to create the painting. Look at the viewpoint, composition, scale and shapes used.
- Refer to the visual elements in your response: tone, colour, shape, texture, light and shade. Remember to explain your remarks.
- State what your opinion is of the painting. You must give reasons why you like or dislike the picture, e.g. I like the painting because of the realism, detail, texture, mood, atmosphere, mystery, etc.

There are clearly three parts to this answer. Break the question down as shown and work your way through each one, and try to get at least 10 good points for each part. The three parts that you break the question down into are worth, in total, **10 marks**.

> ! Think quickly – bullet points are acceptable but try to answer the question in sentences.

Here is an extract from an answer to an **(a)** question. Although the answer is short there are some good points which are awarded marks.

This part is the **description** of the landscape image.

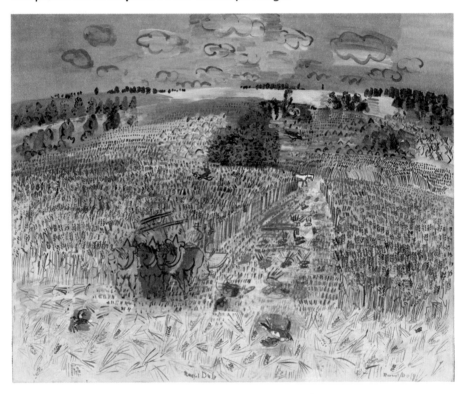

The Wheatfield (1929) by Raoul Dufy, oil on canvas (130 x 162 cm)

4. Natural Environment

(a) Describe this work. What do you think inspired the artist to paint this country scene?

(SQA Int 2 Art and Design Past Paper, 2005)

 The painting is of fields of crops and forests under a blue sky. In the foreground there are horses being used for what may be threshing of the crops. **(This is a good interpretation of what is going on in the painting and is awarded 1 mark.)**

It is painted using bright, contrasting colours to give it a feel of summer, as the colours used for the horses are the same as the bright reds and violets of the flowers we see in that season. **(Good awareness of the use of colour in the painting. 1 mark.)**

There is a feeling of strain on the horses as their heads are bowed as they drag the threshing device. **(Another good observation – 1 mark.)**

The threshing device appears to be primitive or from the past, which suggests that it is a scene from a poor country. **(1 mark)**

The background has considerably less detail than the foreground: long, thin brush strokes are used in the foreground, whereas short, hard strokes are used in the background. **(The points made are backed up by reference to the brush strokes. 1 mark.)**

I believe that the bright colours and the feeling of depth as the crops decrease in size, the further away they are, inspired the artist to paint this scene. **(This is a very good point which shows an understanding of how artists create depth in paintings through the use of light colours, and objects decreasing in size. 1 mark.)**

This part of the answer gives reasons for the artist's inspiration.

The inspiration for this, in my opinion, was the wide open spaces of the wheat fields and the many different colours. **(1 mark)** Within this beautiful landscape hard work is going on which, in some ways, is a contrast. **(1 mark)**

The threshing device also creates changes in texture and pattern. **(1 mark)**

Also the whole scene shows the relationship between nature, man and animals. **(1 mark).**

 When you are describing a painting it is a good idea to refer to the visual elements, e.g. line, tone, colour, texture, etc., and the approach the artist has taken to producing this work.

This approach to Dufy's landscape is very lively, vibrant and semi-realistic approach. Remember, this might not be your own preferred approach to a painting so try to look at the image in a clear objective manner and just describe the painting as you see it. In many examples the image may not be to your liking. That is why it is important to refer to the question and make sure of exactly what is being asked.

Exam Example 8: Question 4 part (b) Natural Environment (Landscape)

The key issue in this question is knowledge and understanding of the artists who produced work using the natural environment as a source of inspiration.

Consider the following points:

- **Inspiration** – what inspired the artist to produce these works based on the natural environment?
- Is their work based on **real observations** or produced from imagination, or from a number of sources, e.g. drawings from the landscape, photographs?
- **Style** – is the work representational of nature (realistic) or derived from nature (abstract)?
- You must be familiar with examples of the artists' work – at least two from each artist.
- You should know the title of the work.
- What **media** is used in the work, e.g. oil paint, watercolour, pastel, charcoal, mixed media or collage?
- **Scale** – is the work large or small? Is there a reason for this?
- Is the work you are referring to typical of the artist's work?
- Are there major **influences** in these pieces of art either from other artists or movements? This may be from another era or from a more contemporary source.
- How **important** were these artists in their lifetime? Did they **contribute** to the genre of landscape/natural environment? Were the artists associated with any **particular movement** or **style**?
- A good answer may include **comparisons** of artists' work and your **preferences**.
- **Likes** and **dislikes** will be rewarded as long as you **back up** your opinions with good points.
- **Conventional** and **unconventional** approaches by artists are points worth considering when you study the working methods of each artist.

 An example of unconventional art would be 'Land Art'. This is a type of art in which the artist uses actual land, earth and stones, combined with other objects, e.g. Christo and Jeanne-Claude '*Wrapped Coast*' (1969), shown on page 73.

Here are two examples from an answer to a part **(b)** question. They are good examples and they demonstrate knowledge and understanding of the artists' work followed by descriptions of their paintings.

> ### 4. Natural Environment
>
> (b) Compare and contrast **two** works by **two** different artists who were inspired by the natural environment.
>
> *(SQA Int 2 Art and Design Past Paper, 2007)*

Example 1

 John Lowrie Morrison is an excellent painter in my opinion. I enjoy the abstract and enthusiastic style in which he paints. He started off his art career after school, and when he left Glasgow School of Art he became well known and began to sell his paintings after a series of exhibitions. **(1 mark. This is a very brief background to the artist's life.)**

He was inspired to paint the Scottish Highlands and rough stormy seasides, using vivid and dramatic brush strokes in a very abstract and distinctive style. **(1 mark. This point refers to his inspiration.)**

A good example of one of his paintings is 'East West Light 11' where we see a rocky shore pointing out into a vivid dark sea and sky. **(1 mark. A reference to an example of his paintings.)**

The brush strokes used for the painting are strong and thick, exaggerating the visual elements of the picture, i.e. colour and tone, which emphasise the darkness of the sky and how wildly the waves are lapping onto the beach. **(1 mark. This is a very good description of the painting and refers to the visual elements.)**

The painting is rather abstract and has a lot of splashes of paint. The wake of waves can be seen gushing into the air from the force of the water. **(1 mark. Referring to style (abstract).)**

The above is an **extract** from an answer.

Example 2

This example shows a similar structure to example 1. It mentions the artist, his work and influences. It also compares the work of two artists from different periods in time.

 John Constable was encouraged from a young age by his father to go on trips around his native Suffolk. Visiting these areas gave the young John Constable inspiration for his early paintings. **(1 mark. This is a brief note on the artist's background and source of inspiration.)**

He was also influenced by such artists as Jacob Van Ruisdael, who was known for his stunningly realistic woodland scenes. **(1 mark. This is good background information and shows the artist's influences.)**

Constable's ability to create depth in work is evident in 'Dedham Vale', a painting of spectacular realism and similar to many of Constable's works, and displays his love for the natural environment. **(1 mark. This refers to an example of his work which shows aspects of depth.)**

In the painting the common countryside scene coupled with the light tones of the sky creates a very mellow, familiar atmosphere. **(1 mark. This is a good description, with reference to visual elements.)**

The mixture of light and dark greens of the woodland in the foreground creates an effective contrast with the pale blue sky of the background. **(1 mark. This is a good use of language in relation to visual elements.)**

The contrast here combines with the subtle finer brush strokes in the foreground, and creates an impression of depth and distance. **(1 mark for use of language in reference to the artist's methods.)**

Similarly to Constable, McIntosh Patrick was inspired to paint his local area, Angus near Dundee. McIntosh Patrick followed a very systematic approach to his working methods. He would take a quick sketch then return to his studio to compose his painting. **(1 mark. There is a brief note on his background and refers to his working methods.)**

A recurring feature in Patrick's work is the use of a path or river to guide the viewer's eye into the landscape. **(1 mark. This point refers to a good understanding of the artist's painting.)**

The painting where I think this feature is prominent is 'Berry Picking, Mails of Grey'. The foreground of this painting is dominated by a light orange pathway which contrasts with the subtle tones in the shrubbery that runs adjacent to the path **(1 mark. This is an excellent description using artistic language and again refers to the visual elements.)**

McIntosh Patrick, similarly to Constable, uses fine and thick brush strokes to create the illusion of depth. The pathway guides the viewer to the focal point of the painting which is a field and a river in the distance. **(1 mark. These two points show a good comparison of how both artists used a technique to create a focal point in a painting.)**

 These two examples of answers show good knowledge and understanding of the artists' work and their methods. They are well-structured answers and refer to specific paintings.

SECTION 2: DESIGN STUDIES

This section consists of six questions covering the six areas of design:

- Question 7: Graphic Design
- Question 8: Product Design
- Question 9: Interior Design
- Question 10: Environmental/Architectural Design
- Question 11: Jewellery Design
- Question 12: Textile/Fashion Design

There are two parts to each question: **part (a)** and **part (b)**.

The **(a)** question will test your ability to respond to an image of work from these areas of design.

In this type of question you may be asked your **opinion** on the design illustrated or you may be asked to **discuss** the design in terms of style, function, target market, aesthetics, practicality and use of materials.

The **(b)** question will test your knowledge and understanding of the work of designers, movements and styles from the period 1750 to the present day.

In this type of question you will be required to **discuss** and **comment** on the work of designers and the styles or movements which you have studied.

> **!** You must answer a full question in section 2, e.g. if you choose Textiles in section 2 you must do the **(a)** and the **(b)** questions for Textiles. Do not attempt to answer any other questions within this section.

We will look at the key issues in these questions and how to answer them.

> **!** Remember, although you may memorise your answer and prepare well for the exam, it is very important to answer the question carefully and not just regurgitate everything you have memorised.

HOW TO ANSWER QUESTIONS IN SECTION 2: DESIGN STUDIES

The following questions are numbered according to the way they would appear in the exam paper.

Exam Example 9: Question 7 part (a) Graphic Design

In the graphic design questions, the illustration may be either a poster, a menu, a playstation game cover, food packaging or a CD/DVD cover.

The important design issues in this question are outlined below.

1. Imagery

Drawings, illustrations, photographs, symbols, shapes, patterns.

2. Lettering/text

Font size, style, colour.

3. Target market

Age group, gender.

4. Technology

Computer-generated images, text.

5. Communication

The success of the design.

We will look at a typical graphic design **(a)** question and break it down to show what is required for a good answer.

Breakfast cereal packaging design for ASDA (2007)

41

7. Graphic Design

(a) What target market is this packaging design aimed at? Refer to *imagery*, *lettering* and *colour*. Do you think it is successful?

(SQA Int 2 Art and Design Past Paper, 2009)

This question can be broken down to three parts.

Part 1: *What target market is this packaging design aimed at?*

This part of the question refers to a group of people who may be attracted to buy this product because of the packaging design images and colours.

Part 2: *Refer to use of imagery, lettering and colour.*

This part of the question requires a more in-depth response and you should be able to discuss in detail the use of imagery, lettering and colours using appropriate design terms, e.g. 'bold simple lettering with a variety of fonts. The background uses gradients of colour as it goes from dark blue to white in the centre.'

Part 3: *Do you think it is successful?*

This is the part of the question where you are asked to state your opinions. You can do this in either a positive or negative manner, as long as you justify your comments.

Here is an example of an answer to the above question which would gain full marks.

This design in my opinion is aimed at younger children and teenagers due to the bright colours, bubble-shaped text and scattered layout. **(1 mark)**

The title 'Choco hoops' has been put in brown lower-case letters, with rounded bubble shapes. This use of lettering gives the design a fun, childish effect which would attract children and parents. **(1 mark)** In the centre of the design there is a bird with a long yellow, pink and green beak, and its eyes form part of the title. **(1 mark)** This gives a humorous, fun side to the design which would attract younger people to the product. **(1 mark)** There are other pieces of text lying diagonally from bottom right to top left. This unusual layout gives an exciting free effect to the design. **(1 mark)**

Hoops of the cereal are scattered all around the packaging, telling kids straight away what the cereal looks like, again encouraging children and parents to buy. **(1 mark)**

The background uses gradients of colour as it goes from dark blue to white in the centre. **(1 mark)** This effect brightens the title and makes it look as if there is light

radiating from it. **(1 mark)** The use of these strips of light is intended to make the children think the cereal is amazing and tasty. It also makes the overall design look modern. **(1 mark)**

The front cover is also repeated around the side of the cereal box to make it look catchy, interesting and eye-catching. I really think this packaging would be very successful because of its colours, images and layout. **(1 mark)**

This answer shows a clear understanding of the key points in the question and each point is well justified. Reference is made to the **imagery** – '*humorous, fun side to the design*' and also to the bird with its '*long yellow, pink and green beak.*' Attention is paid to the **lettering** – '*bubble-shaped text*', '*scattered layout*' and also '*lower-case lettering*'.

A description is given of the **colour** – '*The background uses gradients of colour*', etc.

This answer is very well structured, with good use of design terminology.

 Remember, do not overload your answer with points. This might cause you to run out of time to answer the other questions.

Exam Example 10: Question 7 Part (b) Graphic Design

In this section we will look at the important design issues which you need to be aware of when answering a part **(b)** question on graphic design.

The important points in this type of question are outlined below.

- You must demonstrate knowledge and understanding of the work of two graphic designers.
- You should be able to refer to specific examples of their work.
- You should be aware of how the designers create visual impact in their work, and the techniques and methods used to achieve this.
- You must be able to use important terminology concerning graphic design, e.g. layout of text, use of imagery, coordination of colours.
- You must be able to compare and contrast examples of graphic designers' work. Look for similarities or differences in style, techniques and methods.

 Keep basic background information to a minimum. Marks are mainly awarded for discussing the designer's work.

The important design issues in this question are outlined below.

1. Technique

This refers to how designers produce their work. It could be that the images are hand-drawn, printed or digitally produced.

2. Style

This refers to the images used in the graphic designs. They may be realistic, abstract or semi-abstract shapes. The style of lettering is also very important. This will depend on what is actually being produced, i.e. a poster, menu, etc. Some designers favour a bold lettering style while others prefer a variety of different fonts and colours. The style of the design may relate to a particular movement, e.g. Art Deco, Art Nouveau or the 1960s era.

3. Function

The main purpose of a graphic design is to communicate information through the use of imagery and text. You may be asked if, in your opinion, the designs you are discussing are successful in terms of communication and appeal to the viewer.

4. Target market

Be aware of the target market the designers' work is directed towards, e.g. children, adults, teenagers or a wide range of people. This point will depend on the type of graphic design you are discussing in your example. It could be a poster, cereal packaging or computer game packaging.

Remember, this part of the exam is based on the designers and movements you have studied.

Here is a typical part **(b)** question and an extract from a good answer showing where marks are awarded.

The key words in this question are in bold. The two graphic design images are also displayed to help you see the comparisons the candidate is making. These images would not be displayed in the answer.

> **7. Graphic Design**
>
> (b) **Compare** two graphic designs by different designers. **Identify** and **discuss** the methods used to create **effective designs** with **visual impact.**
>
> *(SQA Int 2 Art and Design Past Paper, 2009)*

The two graphic designs I have chosen to discuss are Victor Moscoso's the 'Rock Music Revival' poster for San Francisco's music hall and Robert Indiana's 'Love' poster for an exhibition theme. **(1 mark)** The two designers have very different visual communication methods, e.g. Victor Moscoso liked to use a mixture of extremely bright colours and text to communicate his ideas. **(1 mark)** Victor used bright colours and fascinating pictures to catch the customer's eye. **(1 mark)** He then used written information to help viewers understand the poster. **(1 mark)**

Robert Indiana, on the other hand, used verbal communication rather than pictures to communicate his ideas. **(1 mark)** Robert's style usually consists of large lettering mounted on contrasting colours to make the text stand out. **(1 mark)** In this particular design I like the bold lettering and the colours used, which are typical of the style used in posters in the 1960s. **(1 mark)**

In my opinion, Victor Moscoso's posters were more eye-catching and useful in relaying information. **(1 mark)** They were exciting and displayed a good use of colour. **(1 mark)** They also communicated more information about the event. Therefore, in my opinion, Victor's work was more appealing and of a better standard than Robert Indiana's. **(1 mark)**

Although this answer is short, the points made about the posters are valid and well justified. There is reference to how images and text are used to communicate a message.

Neon Rose 17, The Blushing Peony (1967) by Victor Moscoso

Love (1965) by Robert Indiana, Greeting Card published by The Museum of Modern Art, New York

Exam Example 11: Question 8 part (a) Product Design

The important issues in product design are the following:

- appearance/aesthetics
- function
- materials used
- style

In a product design question part **(a)**, you may be required to compare designs from different eras and discuss the advantages and disadvantages of these designs and how successful you think they are. The product designs could be a gramophone, cooking utensils, televisions or children's toys, etc.

When answering a part **(a)** question, you should refer to the knowledge you have gained about designers' working methods and design styles.

Gramophone
This early music system is operated by a clockwork mechanism
which requires the user to wind up the handle.

8. **Product Design**

 (a) How does this gramophone compare to today's products for playing music? Refer to *appearance* and *function*.

 (SQA Int 2 Art and Design Past Paper, 2009)

We will look at a part **(a)** question and break it down into the main design points that should be part of a good answer.

 There are 10 marks awarded for a good answer, so make sure you make 10 good, clear points.

In the first part of the question, you should refer to your own knowledge and experience of existing music systems with which you are familiar. Think about how they work and their appearance. Compare them to the gramophone illustrated.

The key points of this question are **appearance** and **function**. Let us look at these two key words in more detail.

Appearance

The appearance of the gramophone in the illustration can be compared to contemporary products. It is much larger and more decorative, whereas modern designs are more compact.

The shape of the horn may be compared with natural forms such as a flower opening out. The decorative carving on the wooden base should also be noted.

Function

You should discuss the function of the gramophone as a piece of furniture, which sits alongside other items of furniture. However, the main function of the gramophone is to play music, but you do not need to know the technology behind this except that it is a wind-up mechanism.

This product has limited functions when compared to music devices of the present era, e.g. MP3 players, iPods, etc., which are more portable and produce a better sound quality.

 In your answer, use appropriate design terminology, e.g. aesthetics, function, style and the materials used.

Here is an example of a good answer. This answer would gain full marks.

 The main differences between this gramophone and a modern device like an iPod or MP3 player are size and mobility. (**1 mark**) The gramophone is a very large design and would be very awkward to move around or carry. (**1 mark**) The MP3 player can be placed in a pocket or a bag, which makes it practical and easy to use. (**1 mark**) The gramophone on the other hand was made a long time ago and in my opinion is very old-fashioned and wouldn't appeal to many people today. (**1 mark**)

The quality of the sound produced by the gramophone would be very poor and crackly when compared to today's devices. (**1 mark**) It would only be able to play very early records, which would be stored separately from the device. Today no records are required for devices since the music is loaded on digitally, thus cutting out the need for physical storage areas for recordings. (**1 mark**) Compared to an MP3 player, which can produce a very high quality of sound and be updated with the latest music almost immediately, the gramophone is very limited. (**1 mark**)

The gramophone is highly decorative and, with its curved base, would certainly make a nice piece of furniture. There is a nice contrast between the metallic horn and the wooden base. The MP3 players and iPods come in many appealing colours but could not be used as a piece of furniture. (**1 mark**)

The gramophone needs to be wound up by its handle in order to produce music. This takes a lot of effort when compared to MP3 players and iPods, which work with the press of a button. (**1 mark**) The gramophone doesn't really compare well to a modern player in my opinion because of its size, which means it cannot be carried around, and the poor quality of the sound it produces. I think I would prefer the modern music systems to the gramophone. (**1 mark**)

Exam Example 12: Question 8 Part (b) Product Design

The part **(b)** question will test your knowledge and understanding of the work of two designers, their working methods, influences and use of materials. You will need to refer to specific examples of their work in detail and be able to compare the work of one designer to another.

If the designer was associated with a particular style or movement, you must refer to this in your answer.

The important design issues related to product design are the following:

- function/fitness for purpose
- use of materials
- style
- sources of inspiration
- use of technology
- target market
- methods of construction
- aesthetics

> Remember, before you can answer a part **(b)** question your Design Studies summary should be complete, covering every aspect of your chosen designer's work. If you have covered those key design points in your summary this should enable you to answer a **(b)** question with confidence.

Here is an example of a typical part **(b)** question.

8. Product Design

(b) Compare and contrast **two** products by different designers. Explain how the designers have attempted to combine *style* with *function* and to what extent they have succeeded.

(SQA Int 2 Art and Design Past Paper, 2007)

This question requires you to write about two designers of your choice, and in particular two specific products. The important words in the question are **compare** and **contrast,** so when you are discussing each product, compare them to each other in terms of **style** and **function,** *e.g.* *'Marianne Brandt's teapot is very stylish and classy. It looks as if it would work well, whereas Philippe Stark's juicer for Alessi is very attractive but I am not sure if it would function well.'*

The last part of the answer requires you to offer an opinion about whether the designs have been successful or not. When you give your opinion make sure that you justify it and use appropriate design terminology.

> Remember that, in your answer, you may include a point related to a product that you own or have bought which is relevant to the question, e.g. a music-playing device.

Here is a well-constructed answer to the question which discusses two products from different designers and also refers to particular styles of the time, i.e. Bauhaus and Memphis style.

In my design studies I have been looking at two different design styles from different periods. They are the Bauhaus School from the 1930s and the Memphis Group of designers that was formed in 1981. **(1 mark)** The Bauhaus School was started by Walter Gropius in Weimar Germany.

They wanted to create a design school where all the arts came together to produce designs which were modern, functional and had a wide appeal to the public. (**1 mark**) These designs included graphics, furniture products and architecture. (**1 mark**)

One of the designers who attracted my attention was Marcel Breuer, who was a student at the Bauhaus and then taught there. (**1 mark**) He created many interesting furniture designs which I like and he tried to follow the principles of the Bauhaus, which were: clean, sharp lines, no ornamentation and very functional. (**1 mark**)

A good example of one of his designs is the 'Wassily Chair', which was revolutionary at the time because it combined bent tubular steel and canvas. The design was apparently inspired by the tubular handlebars on Breuer's bicycle, which I think is brilliant. (**1 mark**) I really like this design because it is very stylish, modern, and I think it would be quite comfortable, though only for a short time. (**1 mark**) He designed a 'Long Chair' in 1930 which was also very stylish. This chair was the first to experiment with bent and formed plywood and for its time it was very modern. I think both designs by Breuer are very successful. (**1 mark**)

Another designer I have been looking at is Ettore Sottsass, who formed the Memphis Group in the 1980s. Sottsass and the other designers in the group wanted to design products which were exciting, colourful and in many ways shocking and unconventional, which I think they succeeded in doing. (**1 mark**)

One of Sottsass' designs is the 'Carlton Room Divider', which is a brightly coloured bookcase and was made from laminated wood. (**1 mark**) The bookcase has shelves coming out at strange angles, which is a bit weird. It is like a piece of sculpture, with hard edges and flat shapes, but I also think it is very attractive and would probably hold a number of books ,which fulfils its main purpose. (**1 mark**)

Sottsass also designed the 'Casablanca Cabinet' in 1981, which is also a very stylish and modern-looking bookcase. I think is a good piece of design and very functional. (**1 mark**)

I think these designers have succeeded in producing good designs which are very stylish in appearance and look as though they would function reasonably well. (**1 mark**)

I also like the way these designers used different materials like laminated wood and tubular steel. The designs, particularly the chairs by Breuer, still look modern today. (**1 mark**) Of the two design styles I think I prefer the Memphis Group because their work is really unusual and exciting to look at and quite daring for its time. (**1 mark**)

Wassily Chair (late 1927 or early 1928)
by Marcel Breuer

Carlton Room Divider (1989)
by Ettore Sottsass

This is an excellent answer and would be awarded the full 10 marks (remember the maximum marks awarded can only be 10 even though 15 are given).

In the answer there are references to two styles of design, the Bauhaus School and the Memphis Group.

Referring to movements or styles of design is acceptable as long as you answer the question. In this particular question two products by different designers are discussed with reference to their design styles.

There is a good understanding and knowledge of the designers and their work. The answer concludes by stating an opinion on the success of these designs and preference for one designer over another.

Exam Example 13: Question 11 Part (a) Jewellery Design

When answering a part **(a)**, question it is important to refer to the main design issues which relate to jewellery design.

Wristwatch by Boucheron (1942).
Materials: gold set with diamonds and saphires

11. Jewellery

(a) What is your opinion of this piece of jewellery? Refer to *style*, *materials* and *fitness for purpose*.

(SQA Int 2 Art and Design Past Paper, 2009)

The question has been broken down into the three main points, which are **style, materials** and **fitness for purpose**.

This question requires you to give your opinion on this watch, but you must refer specifically to **style, materials** and **fitness for purpose**.

1. Style

Look at the information below the image which states that it was made in 1942. You may recognise the **style** as Art Deco. The geometric forms and shapes are also a very important part of the watch. The shapes are repeated throughout the design.

2. Materials

The information states that the design has been made with expensive, precious metals and stones, which would suggest that the item is an upmarket product and would be expensive. At this point in the answer, you may offer an opinion on whether you think the choice of materials was successful.

3. Fitness for purpose

This part of your answer should refer to the basic function of the watch, i.e. how easily the time can be read, how the watch would be fastened and also the comfort for the wearer.

In your answer you may refer to the expensive nature of this watch as a 'status symbol' as well as a timepiece. You should also speculate on who would wear such a watch.

Here is a good answer which gives a detailed description of the watch and refers to the main points of the question.

 The wristwatch designed by Boucheron is really appealing to me. The style of the watch, with its almost snakeskin-look wristband, gives an impression of good quality. **(1 mark)** It looks very stylish with its odd looking clock face and looks seems as if it would stand out while being worn. **(1 mark)** The watch looks like something from the Art Deco era with its bold geometric shapes which are a main part of the design. **(1 mark)**

The materials used are gold, sapphires and diamonds, which are precious, valuable materials that are worth a lot of money. I think this is an excellent choice of materials for this watch. **(1 mark)** The watch does look like it has been cold connected together. The sapphires on the top of the clock face shape look angular, making the appearance very attractive. **(1 mark)**

The watch in my opinion is definitely fit for purpose as it can be worn on the wrist. It looks as if it can be fastened easily and displays the time clearly in my opinion. **(1 mark)** I think it is for females, due to the round shapes, link wristband and purple sapphires. **(1 mark)**

The white diamonds have a sparkling effect which is an attractive feature on the watch. **(1 mark)**

I really like this watch as it is very stylish, rich-looking and well made although wearing it may be uncomfortable. **(1 mark)**

In my opinion I think the watch is mainly worn as a fashion accessory rather than a functional timepiece. Some people may use it as a status symbol to be worn on special occasions since it is so expensive. **(1 mark)**

This answer would achieve full marks since it addresses the main points of the question, which are **style, use of materials** and **fitness for purpose.**

Exam Example 14: Question 11 Part (b) Jewellery Design

This part of the question requires you to demonstrate your knowledge and understanding of two jewellery designers.

You should be able to discuss and offer opinions on specific examples of their work and explain how each designer has created their designs.

In your answer you should also refer to the designers' sources of inspiration, their working methods and preferred techniques and materials.

You should also be aware of the target market the designer is aiming at.

Your answer may focus on two design movements or designs of jewellery. This is acceptable depending on the wording of the question.

Some questions may ask you to compare the work of one designer with another. In this type of question you must consider any similarities or differences in their sources of inspiration, techniques, style and working methods.

Here is an example of a typical part **(b)** question. The focus of this question is on the **comparison** of two designers' **inspiration** and **techniques.**

11. Jewellery Design

(b) Select **two** examples of jewellery by different designers.
Compare the different sources of inspiration and techniques used to produce visually exciting pieces of jewellery.

(SQA Int 2 Art and Design Past Paper, 2009)

 In my design studies I have been looking at the work of two jewellery designers who I really admire. The first is the French jeweller René Lalique, who designed jewellery in the Art Nouveau style which was around the late nineteenth century into the early twentieth century. **(1 mark)**

The other designer is Stephen Webster, who is a contemporary designer from Britain. He is very popular at the moment, particularly with some celebrities. **(1 mark)**

René Lalique, like many other Art Nouveau designers, was influenced by nature and used flowers, plants and occasionally figures in his designs. **(1 mark)**

I really like his use of colours, i.e. gold, purple and pinks, and also like the way he used rich jewels in his designs. **(1 mark)**

Lalique was also influenced by Japanese artworks which had plants and animals in them. **(1 mark)**

One of the examples I like the most is the 'Iris Bracelet' made in 1897. It was made with gold, enamel and opals. It has lovely rich purples and blues bordered by gold. **(1 mark)** In my opinion it looks like a very upmarket piece of jewellery and has a very effective appearance. **(1 mark)**

The other example I like is 'Deep Pufferfish Cocktail Ring' by Stephen. He is very good at combining precious and semi-precious gemstones together into highly detailed pieces of jewellery. **(1 mark)**

He uses sealife as his source of inspiration and one of his collections is called the 'Jewels Verne Collection', which has great examples of earrings, rings and bracelets. **(1 mark)**

In my opinion he seems to have a strange sense of humour as one of his designs I like, 'Deep Puffer Fish Cocktail Ring', is inspired by the poisonouns sea creature. This piece was made with white gold, set with black diamonds and red coral. **(1 mark)** I really like this design because of its clever use of materials and its originality. **(1 mark)** His highly detailed work is very interesting. It would probably appeal to people who have plenty of money and want to make an impression. **(1 mark)**

Although Lalique's designs were produced many years before Webster's there are some similarities in their approach. Both used nature as a source of inspiration. **(1 mark)** However, Lalique used themes from nature which are pleasing to look at in their natural environment. He reproduced this in his colourful designs. **(1 mark)** Webster used themes from nature that are less pleasant to look at in their natural environment but turned them into something beautiful in his highly detailed designs. **(1 mark)**

In my opinion Lalique's designs are much more colourful, functional and appealing than Webster's designs. **(1 mark)**

This is an excellent answer. It demonstrates a good understanding of the designers' work. It makes important comparisons and refers to the designers' sources of inspiration.

There is also reference to the Art Nouveau style, which Lalique's work was associated with at the time.

This answer would achieve full marks.

Exam Example 15: Question 12 Part (a) Textile/ Fashion Design

In this section we will look at the important design issues relating to textile/ fashion design.

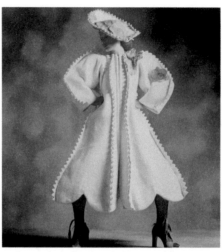

Dinosaur coat and hat designed by Zandra Rhodes (1971). Materials: woolfelt, printed silk lining and appliqué silk flowers.

11. Textile/Fashion Design

(a) How successful is this outfit? Refer to sources of *inspiration, form* and *detail.*

(SQA Int 2 Art and Design Past Paper, 2009)

The first part of this question allows you to state a personal opinion on the success of the outfit. Your opinion may be negative or positive as long as you justify these points.

Remember to use design terms in your answer when you justify your opinions, e.g. aesthetics, use of materials, style and construction techniques.

The second part of the answer requires you to suggest the sources of inspiration used in the design and how effective it looks.

You should also refer to the finer details of the design.

Here is a good example of an answer, which shows an understanding of design terminology, and refers to the sources of inspiration the designer has used to create the design.

The answer is well structured and deals with the two main points in the question in the order they appear.

 I think this outfit created by Zandra Rhodes is a really successful and exciting design. The outfit is good because it seems to be based on two main sources of inspiration. **(1 mark)** Firstly, there seems to be a reference to a dinosaur. You can see that from the zigzag-scalloped edges, which look like the back or tail of a dinosaur. **(1 mark)** Secondly, Rhodes has used flowers which are attached to the coat, possibly for decoration. **(1 mark)**

There are also flower patterns used on the lining, which work quite well in my opinion and add detail to the design. **(1 mark)**

I also like the way the coat has been constructed. It is big and bold and seems to be well made with good materials, i.e. wool felt and silk on the inside. **(1 mark)**

The inside lining is really attractive but the stronger material has been used on the outside. **(1 mark)** I think you can see the seams on the outside but that doesn't adversely affect the overall look of the design in my opinion. **(1 mark)**

I also like the curved shape of the hemline. This might be from the shape of a flower petal, which adds a nice bit of detail to the coat. **(1 mark)**

The colours used in the outfit are soft and feminine and go well together, with nice contrasts of colour in the hat **(1 mark)**

I also like the hat, which reflects the shapes and patterns used in the coat, particularly the applied flower design, which adds detail and completes the whole look of the outfit. **(1 mark)**

Finally, I think Zandra Rhodes has created a really successful, classy design because of the overall shape, the details of the flowers and her good use of materials, although I am not sure on what occasion you would wear this outfit. **(1 mark)**

This response would get full marks. The candidate has given a good description of the image and has used design terms to justify his/her opinions.

Exam Example 16: Question 12 Part (b) Textile/ Fashion Design

The main issues in these questions are:

1. The designers' work

You must be familiar with examples of the designers' work, when it was produced, the main characteristics of the design, and if the design was produced for a particular collection or fashion show.

2. The designers' working methods and techniques

You should be familiar with how your chosen designers create their designs. The particular techniques and materials they prefer to use must also be mentioned, and what influence they had in their own particular area of design.

3. The designers' source of inspiration

In your answer state the sources of the designers' inspiration, e.g. nature, other cultures or from experimenting with materials, colours and textures.

4. Target market

You should be aware of the target market that the designers are aiming at. It may be a particular age or social group, celebrities or simply a wide range of people.

Here are examples of **(b)** questions you may be asked in an exam.

Example 1

Discuss the work of **two** textile or fashion designers. Identify the most important features of their designs.

Example 2

Select two examples of work by different textile or fashion designers. Explain how these examples are typical of each designer's individual style. Refer to their sources of inspiration and use of materials.

Example 3

Compare two examples of work by different textile and fashion designers. Comment on their use of materials and source of inspiration.

The first example is a general **discussion** on designers' work with reference to the main **features** of their designs.

The second asks you to discuss **two specific examples,** referring to their individual style.

The third is a **comparison** question.

There are **10 marks** available for part **(b)** questions. Good knowledge and understanding of your chosen designers and their work is necessary to answer these questions. Your answers should be well informed, structured and refer to specific examples.

There follows an Example 1-type question and tips on how best to answer it.

12. Textile/Fashion Design

(b) **Discuss** the work of **two** textile or fashion designers.
 Identify the most important features of their designs.

(SQA Int 2 Art and Design Past Paper, 2010)

The first part of your answer should discuss briefly the two designers you are going to write about.

State the important points about the designers. Do not overload this part of your answer with unnecessary information.

After this introduction to your answer, begin to discuss the work of each designer one at a time. Refer to examples of the designer's work, with special attention being paid to use of materials, style and themes.

When you are discussing the designer and the examples of their work, you must refer to their working methods, i.e. how they create their designs and their sources of inspiration.

Identify what you think are the most important features of their work, e.g. a traditional look, printed fabrics or an interesting combination of materials.

Remember, after discussing your first designer, go on and discuss the second following the same structure as already outlined above.

Although the question does not require you to **compare** the work of these two designers, you should consider some form of comparison after discussing their work. A comparison should discuss similarities or differences in approach, style and use of materials.

Finally, state your preference for one of the designers and give your reasons.

Here is a well-structured answer to the question.

Two designers that I have studied are Vivienne Westwood and Stella McCartney. Both are worldwide respected designers; however, they each have their own distinctive fashion style. **(1 mark)**

Vivienne Isobel Swire was born in 1941 and at the age of sixteen attended Harrow Art College. Vivienne first started designing in 1971 and by 1981 had created her own collection in London named 'Pirates'. **(1 mark)**

In 1985 Vivienne designed the 'Mini Crini' collection, which included an increasingly shaped look with masculine shoulder pads and tight fittings to the hips. **(1 mark)**

The collection also had a variety of stars and stripes and polka dots, which complemented the female form, but appeared outrageous at the time. **(1 mark)**

Vivienne was inspired by the street style of rebellious youth, and the use of historic and ethnic garments. **(1 mark)**

She has had many worldwide fashion collections which included the mini kilt with stockings and Harris tweed jackets. **(1 mark)** In her collections she has included the bustle, which was designed in the nineteenth century to make women appear more slim. **(1 mark)**

As a result of Vivienne's fearless yet traditional approach she did not hesitate to experiment with natural or synthetic materials such as wool, tweed, latex, leather and fur. **(1 mark)** Some of her other designs included tartan as a source of inspiration which I find really interesting. **(1 mark)**

The other designer I studied was Stella McCartney, who was born in 1971. She is the daughter of ex-Beatle Sir Paul and photographer and vegetarion campaigner Linda McCartney. **(1 mark)**

Following the death of Stella's mother Linda in 1998 she joined with PETA to make people more aware of cruelty to animals and therefore she only produces designs using natural materials such as wool. **(1 mark)**

In 1997 Stella was chief designer at the House of Chloe and in Paris that year her first collection was launched which included lace petticoat skirts and a nineties makeover of a sixties trouser suit. **(1 mark)**

Stella also used plastics and fabrics to make shoes, and raffia in her designs for bags and hats. **(1 mark)**

By using natural fabrics and tailoring garments to fit the female form, she creates a professional look with a touch of femininity. **(1 mark)** Her dress jackets complement tight jeans and her ponchos, wraps and shirts are all made from wool and cotton. **(1 mark)**

Stella's 2007 summer collection included smocks, long-sleeved shirts, short dresses and double-layered mini skirts. **(1 mark)** They were created using silky sky blues and sea greens, with raffia sandals to complete the summer/natural look. **(1 mark)**

I think these two designers are fantastic and I love their work, particularly Stella McCartney because of the interesting combination and use of natural fibres. **(1 mark)**

This answer would achieve full marks and shows a good understanding of both designers' work. It refers to use of materials, sources of inspiration and particular examples in their collections.

INTERMEDIATE 2 EXAM PREPARATION

Before you sit the exam there are several things you can do to prepare for it.

Practise answering both **(a)** and **(b)** questions in your chosen areas of Art and Design Studies from past papers. These can be obtained from the SQA's website. Hard copies can be obtained from SQA-approved publishers.

Practise answering questions in the set time. This is approximately 15 minutes for each part of the questions. This will give you an idea of time management for the exam. It will encourage you to think quickly and give you practice in organising the thoughts which need to be put down on paper.

Art Studies Summary

- In **part (a)** questions you answer a question on an image of a drawing, painting or a piece of sculpture.
- Look at different images from the visual arts when practising this question, e.g. still life, landscape, portraits.
- 10 marks are available. Make 10 clear points and justify them.
- A good knowledge of the visual elements is required.
- Be able to state opinions on works of art. Give reasons why you like or dislike them.
- In **part (b)** questions you are required to have a good knowledge and understanding of two artists or a particular movement in art history. This knowledge is gained through your Art Studies.
- Try to remember at least two pieces of work from each artist.

 Note down:

 - The key visual elements of each work.
 - The characteristics of their work, i.e. style, scale, subject matter and themes, the artists' working methods and their use of media.
 - Think about how important these artists were and how they contributed to a particular form of art.

- Remember to state your reasons for admiring their work, and give your opinion on it.
- Practise comparing one designer's work to another with regard to style, approach and working methods – are there any similarities or differences?

Annotation of a Painting

A good way to prepare or practise for a **part (a)** question is to look at an image of a drawing, painting or piece of sculpture and note down the important visual elements on the image.

You can also note down any other feature of the artwork that you think is important.

Annotating can help you visualise an artist's work and help you describe the image.

This can also help you to answer a **part (b)** question.

Preparation for a design question can also be done in exactly the same way, e.g. you could annotate the image of a poster or a textile design or whatever you have been studying.

Expression of light and colour in clouds and sea

Loose, impressionistic style

Rapid, rough brushwork

Broad energetic handling of the medium

Naturalistic colour

Link between handling of media to visual elements

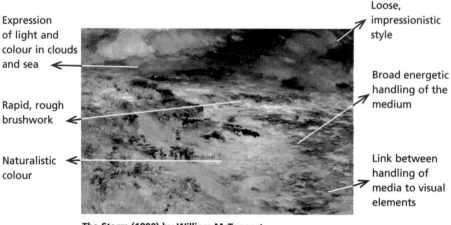

The Storm (1890) by William McTaggart, oil on canvas (122 x 183 cm)

Design Studies

In **part (a)** questions you answer a question on an illustration of an example of design. Before you sit the exam look at different images related to your chosen design area, e.g. posters, products, jewellery, textiles, etc., since the image shown in the exam paper may be unfamiliar to you.

- 10 marks are available. Make 10 clear points and justify them.
- Be aware of design issues, e.g. function, style, aesthetics and techniques.
- Give an opinion on the success of the design.
- In **part (b)** questions you are required to have a good knowledge and understanding of two designers or styles in design, with particular reference to examples of their work. This knowledge is gained through your Design Studies.
- Note down two examples of each designer's work, and their sources of inspiration.
- Be prepared to comment on the characteristics of their work, i.e. the use of materials, their techniques and style.
- Think about these designers and their importance to their areas of design.
- Remember to state your reasons for admiring their work and give your opinion on it.
- Practise comparing one designer's work to another with regard to style, approach and working methods – are there any similarities or differences?

Sitting the Intermediate 2 Exam

The exam lasts for 1 hour. Spend approximately 30 minutes on Art Studies (Section 1) and 30 minutes on Design Studies (Section 2).

The time allocated includes reading the questions carefully, studying the image and the information provided, and getting your thoughts together.

 Only attempt the questions which relate to the areas you have studied. Do not answer a question on Landscape if you have been studying Still Life or a question on Textile Design if you have been studying Graphic Design.

You **must** answer one full question, parts **(a)** and **(b)**, from each section. Do not attempt to answer more than one full question in each section.

If it helps, highlight important words in the question, e.g. words like **compare**, **contrast, inspiration, techniques, tone, colour, function**, etc. Breaking up the question like this will ensure that you cover all the points asked of you.

HIGHER ART AND DESIGN PAPER 2 PART (a) QUESTIONS

The **part (a)** of any question is there for you to demonstrate your critical skills. Critical skills are about your ability to analyse, discuss, comment upon, judge and evaluate art and design objects.

HOW TO ANSWER A PART (a) QUESTION

There are many ways of improving your skills in answering part (a) questions. For example, in **Art Studies**:

1 **Understand and use the visual elements.** The visual elements are things that artists use to make their artworks. They are: colour, tone, line, shape, pattern, form and texture. In most artworks at least three elements appear, but not usually all seven of them together. You must refer to the visual elements in your answer.

2 **Consider artists' techniques.** Artists also use other techniques to create artworks:

- **Media:** paint, charcoal, wood, bronze, photography, etc. Remember, an artist will have chosen their media for specific reasons: to emphasise texture or tone or any other visual element. If it is three-dimensional, ask yourself whether the artist uses natural or man-made materials.

- **Mood/atmosphere:** artists can create a sense of a feeling through careful use of the visual elements. This can remind you of something or trigger a memory or emotion.

- **Message:** some artists use artworks to convey a message about human relationships, or political or social issues. Some artists do not. Be careful not to read everything as symbolising something else; just because an artist uses red it might not symbolise love or danger or heat. Often red is just red!

- **Composition:** how is the artwork arranged? If it is two-dimensional, how has the picture been arranged, can it be divided into thirds or has it got a strong diagonal, for example? How has it been arranged in terms of foreground, midground and background? If it is three-dimensional, is it geometric and regular or organic and natural?

3 **Give your opinion:** often in part (a) questions you are asked for your own opinion. This may seem like a very easy thing, and it is – as long as you back it up with a reason! Writing '*I like it because it looks nice*' will not get any marks as you have not employed appropriate art and design vocabulary. '*I find the painting very intriguing as the artist's use of dark tones creates a gloomy, mysterious atmosphere*' is a far better, fuller answer as it refers to a visual element **(tone)** and an artist's technique **(atmosphere)**.

In Design Studies:

1 A successful design is something that looks good and does its job well. This can be thought of as a very simple equation:

Good Design = Good Aesthetics + Good Function

Aesthetics in design is about how good or attractive something looks. **Function** is concerned with how something does its job.

For example, you might have a tin opener that does its job very well – but doesn't particularly look good. Or you might have a pair of shoes that you think look great – but they hurt your feet when you wear them!

Really successful design is when both aesthetics and function work well together. Although sometimes you have to think very carefully as to what the function of some designs is – especially in the areas of jewellery and fashion, as often aesthetics are the more important of the designer's considerations.

Understand and refer to **design issues** when answering a question; in questions they are sometimes called **design considerations** or **important issues**.

2 A designer usually thinks about certain things when making a design in order for the design to be successful. You should refer to these things (or **issues**) when commenting on and discussing how successful the design is. These are explained in the **Glossary of Design Terms** on page 107.

Let's look closer at how to answer some questions. Each **Exam Example** will help you identify ways to boost your grade.

COMMENTING AND DISCUSSING

Exam Example 1: Question 1 part (a) Portraiture

Here is a typical part **(a)** question. This example focuses on the importance of commenting and discussing.

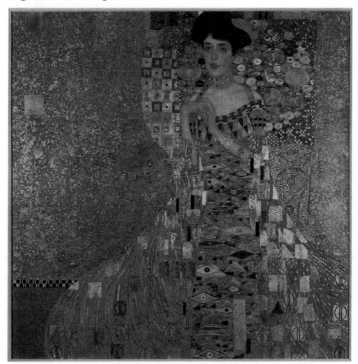

Portrait of Adele Bloch Bauer (1907) by Gustav Klimt, oil, silver and gold on canvas (138 x 138 cm)

1. Portraiture

(a) Discuss the methods used by Klimt to portray the character of the sitter.

 Comment on at least two of the following:
 composition; colour; pattern; pose.

 What is your opinion of the painting?

 (SQA Higher Art and Design Past Paper, 2007)

Let's look more closely at the question. The answer is worth **10** marks – therefore you must say at least 10 things. There are two key words in the question: **Discuss** and **Comment**.

Here are two extracts from two different answers:

1. The woman is on the right-hand side of the painting and there is a lot of pattern behind her. The artist Klimt has used gold and there are swirls and red squares with lots of tiny details. The woman looks sad.

2. In this painting by Klimt there is a huge contrast in the surface of the painting. The woman's face is pale, smooth and flawless; however the background is encrusted with gold swirls and pattern that lead the eye around the figure of the woman in a flowing movement. Klimt shows his skill in handling paint and creating a very eye-catching painting. The woman looks withdrawn and thoughtful and seems to ignore the riches that surround her.

The first response is weaker than the second. The second extract is obviously much fuller. The first merely describes, whereas the second extract provides **comment**. This is a very important point. At Higher level you will not be asked to **describe** – you will be asked to **comment** or **discuss**. Describing is just writing about what you see and at its lowest level can just end up being a list. **Commenting** or **discussing** is description backed up with additional thought. These comments can then begin to illustrate your **opinion**.

 You need to make sure each of your statements is backed up with a reason or with evidence.

HOW TO STRUCTURE YOUR PART (a) ANSWER

Exam Example 2: Question 1 part (a) Portraiture

Let's look at another part **(a)** question. This example will focus on how to use the question to create a structure for your answer.

> 1. **Portraiture**
>
> (a) Discuss the methods used by the artist to reveal aspects of his father's character to us. Comment on *composition, use of visual elements* and *handling of paint*. Explain your personal reaction to this portrait.
>
> *(SQA Higher Art and Design Past Paper, 2006)*

This question is from the **SQA 2006** paper. Without seeing the image, let's analyse what exactly the question wants from us. A good way of tackling questions is to break them down into **parts**. Part **(a)** questions are usually in three parts. It's a good idea to tackle each part one at a time.

Note down key words in the margin of your paper to ensure you don't miss any part out. For the example above you could write the following in the margin:

Character
Composition, visual elements, paint
Reaction

 By ticking these off as you write your answer you can check that you've not missed anything. Remember, you have to make at least 10 statements that answer the question and are backed up with evidence or reason.

You will not get any marks for merely repeating the information underneath the image – **you must comment**.

HOW MARKS ARE ALLOCATED FOR PART (a) QUESTIONS

There are a maximum of 10 marks available for any part **(a)** answer. Markers want to award marks. You will get a mark for any justified comment that answers the question. It is possible to get full marks for a question – many people do! The good thing is that no two candidates' answers are the same and yet they can still be awarded full marks.

Remember, SQA marking guidelines state that: **any justified opinions/views will be rewarded**.

Therefore, an opinion such as the following will be awarded a mark because it is justified with a reason:

 It's also good to wear jewellery sometimes that's not made from expensive materials as you will wear it more often as you will not be afraid that you will lose it.

This is a good example of a personalised opinion that is backed up with a reason.

Part **(a)** questions do not all follow the same structure year in and year out. Look carefully over past paper questions and note the range of different kinds of questions.

Exam Example 3: Question 3 part (a) Still Life

This example will show you how marks are awarded.

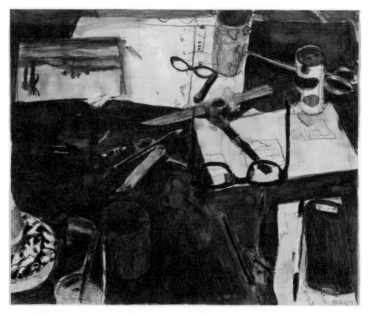

Still Life (1967) by Richard Diebenkorn black ink, conté crayon, charcoal and
ballpoint pen on paper (35.2 x 42.5cm)

3. Still Life

(a) Analyse this still life by explaining which features of the work
you admire and think are successful. Contrast them with
aspects you think are less successful.

(SQA Higher Art and Design Past Paper, 2009)

Here are the marking instructions issued to markers for this question by the SQA:

*In their analysis of this still life, candidates may comment on the use of mixed
media and the loose, expressive style of the work. The random arrangement of
objects within the composition may also be seen to be important. The strong
monochromatic tones may also be commented upon. The question requires
candidates to contrast aspects of the still life they admire with those they think
are less successful. Any justified opinion/argument should be rewarded.*

Marking instructions and past papers are available online at the SQA's website. The marking instructions above are broad enough to cover all possible answers but the key point is the final one: **Any justified opinion/argument should be rewarded.**

Let's split the question into **parts**:

- **Analyse successful features**

- **Contrast with unsuccessful**

This is an interesting question as it asks you not only to comment and give opinion on positive aspects, but also to contrast these and give comment and opinion on aspects that are negative.

Let's look at a good answer to this question:

The thing I like most about this painting is the strong use of tone, which sets a really dramatic scene for the painting. Using tone, Diebenkorn creates a very effective focal point two thirds up from the bottom and two thirds in from the left. This is the most interesting part of the picture and we know that the artist has deliberately chosen this as his focal point as he knows it is an effective area to catch the attention of the viewer. The composition of this picture is very unusual and the objects seem to be arranged randomly scattered on a table. This is a sort of diagonal composition as the most interesting parts seem to make a diagonal line – from the tea cup in the bottom left, to the scissors and glasses in the top right. The artist's media-handling is heavy, with the brush strokes very noticeable. The picture also has a rather sketchy appearance, which again adds to its appeal. Some may criticise his uncontrolled style in this picture but I think that this is a successful part of this painting as it appears to be professional and well executed. The main visual elements of this picture are tone, line and possibly texture in the way he uses the brush. However, tone is the most dominant visual element and I think Diebenkorn has used this successfully.

This answer was graded at 8 out of 10. Why?

Well, let's look at it again with the marks highlighted after each justified comment in the answer:

The thing I like most about this painting is the strong use of tone, which sets a really dramatic scene for the painting. **(1 mark)** Using tone, Diebenkorn creates a very effective focal point two thirds up from the bottom and two thirds in from the left. This is the most interesting part of the picture and we know that the artist has deliberately chosen this as his focal point as he knows it is an effective area to catch the attention of the viewer. **(1 mark)** The composition of this picture is very

unusual and the objects seem to be arranged randomly scattered on a table. **(1 mark)**
This is a sort of diagonal composition as the most interesting parts seem to make a
diagonal line – from the tea cup in the bottom left, to the scissors and glasses in the top
right. **(1 mark)** The artist's media-handling is very heavy, with the brush strokes very
noticeable. **(1 mark)** The picture also has a rather sketchy appearance, which again adds
to its appeal. **(1 mark)** Some may criticise his uncontrolled style in his picture but I
think that this is a successful part of this painting as it appears to be professional and
well executed. **(1 mark)** The main visual elements of this picture are tone, line and
possibly texture in the way he uses the brush. However, tone is the most dominant visual
element and I think Diebenkorn has used this successfully. **(1 mark)**

This answer shows an understanding of various visual elements and artists'
techniques. Tone, line and texture are commented on. Composition and brush
marks are also commented upon. Remember, these terms did not appear in
the question and it is to the person's credit that they have used the correct
vocabulary in their answer.

Why did it not get full marks?

The answer to this is really that they needed to write some more. There are
eight clear points the candidate makes – there is a slight repetition of comments
about tone and it's almost as if they are running out of things to say. The
answer comments that *some may criticise* but then goes on to be positive.
However, the question asks you to *contrast* successful parts with parts you
think are less successful and therefore this example does not fully answer the
question. Just two more justified comments, that used appropriate vocabulary
and answered the *contrast* part of the question, would have resulted in full
marks. They could have commented on the artist's choice of subject and what
this reveals about his working environment. Comments could have been made
on the artist's choice of mixed media. There are countless other things that could
be commented on, but remember – **any justified comment would be rewarded.**

Exam Example 4: Question 4 part (a) Natural Environment

This example shows you how to use a structured approach to answer a
challenging or unusual question.

Christo and Jeanne-Claude *Wrapped Coast* (1969). The coastline of Little Bay,
Australia, wrapped in fabric and rope.

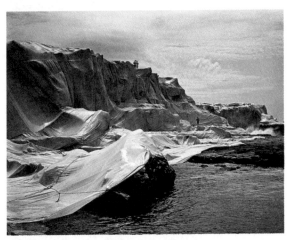

Wrapped Coast, One Million Square Feet
(1968–69) by Christo and Jeanne Claude.

4. Natural Environment

(*a*) Discuss the methods used by the artist to create this example of Land Art. Comment on the use of materials, scale and choice of site. Explain your personal reaction to this work.

(SQA Higher Art and Design Past Paper, 2006)

This is a really challenging question! Most people expect their part **(a)** artwork to be a painting. But, remember, art can be sculpture, found objects, photography, drawing, installation and performance art. Try to keep your mind open and expect the unexpected.

Look through the past papers, either published or on the SQA's website. You will see most of the Art Studies part **(a)** questions are about paintings – **but not all!**

Familiarise yourself with art forms other than painting – ask your teacher for advice.

In the 2006 paper the following definition of Land Art was included to help people understand the art form:

Land Art – a type of art in which the artist uses actual land, earth and stones combined with other objects.

Let's look at a good answer to the question. The question parts are:

- artists' methods
- materials, scale, site
- reaction.

 This is a very unusual and dramatic form of art as usually we would expect a landscape artist to paint the subject. In this case the artists have used the actual landscape to create the piece instead of trying to represent it. **(1 mark)** The artists must have worked very hard to wrap such a big space with the fabric and rope. This must have taken a very long time, with the artists returning day after day to work on each part. **(1 mark)** The fabric looks like silk and it is interesting how it smoothes over the rugged rocks, making them appear quite surreal. **(1 mark)** The ropes obviously hold the fabric down so it doesn't blow away but it also makes it look mysterious, like a strange wrapped present. **(1 mark)** Most artists paint the landscape much smaller than it really is but Christo and Jeanne-Claude have created this Land Art that is life-size and you can actually walk along it. **(1 mark)** I think the site is a good one as it is where the land meets the sea and the smoothness of the silk is like the smoothness of the water. **(1 mark)** Also in the photo you can see big waves splashing up against it which also adds to the dramatic feel. **(1 mark)** I like this as I have never seen anything like it before and it shows how an artist can go to a place and transform it. **(1 mark)** It looks like it would make you want to go and see it if you lived nearby and it might make you see the coastline in a new way. **(1 mark)** I think it is good that artists can show us the world in a new way by taking simple materials like fabric and rope and creating something weird and magical. **(1 mark)**

This is a very well-written answer that follows the structure of the question, uses the correct vocabulary and also is very strong in describing personal reactions. Words such as **unusual, dramatic, surreal, mysterious, weird** and **magical** really help to give depth to the thoughts and feelings.

One other reason, that this answer gets full marks, is that the writer makes 10 well-justified points that are relevant to the question.

 Make the time to read over your answer and count how many justified points you have made. You won't get 10 marks unless you say at least 10 things!

Exam Example 5: Question 7 part (a) Graphic Design

This example shows the importance of breaking the question into parts to answer each part of the whole question.

Tekken 4, cover design for Sony Playstation 2 game (1997)

7. Graphic Design

(a) Comment on the use of technology in this graphic work. What does it communicate about the product and the target market? What is your personal opinion of this style of graphic design?

(SQA Higher Art and Design Past Paper, 2008)

The cover for the game Tekken 4 is for the Sony Playstation. I think this game is for boys as it shows men on the cover and it looks like there would be a lot of action in it. **(1 mark)** The game looks old-fashioned; you can tell this from the graphics used and the use of lettering. I think this game would not be very popular as today's games are much more sophisticated and have more realistic graphics. **(2 marks)** The game looks interesting because the guy on the right-hand side looks like the Terminator and the man in the middle looks mysterious because you can't see his face. **(3 marks)**

This is a weak answer to the question. The reason for this is the answer does not address all parts of the question. The answer gives opinions, but they are not fully justified. This answer does not show a full understanding of design issues. It does not use the vocabulary of the question and it does not make 10 justified comments.

If we break the question into parts, it might be easier to see which points were not fully addressed:

- **Technology**
- **Communicate/target market**
- **Opinion**

Technology, communication and target market are the key points in the question that were not commented on in detail. Although the answer mentions the game is for boys, it doesn't show a full understanding of the target market. Technology is not directly referred to although *realistic graphics* is mentioned. The final sentence is a valid opinion – but it is not dealt with in much detail.

Graphic design is usually about communicating something to a particular audience. This question is quite straightforward in many ways. Technology is always advancing and developing, but a key thing to remember is that, although some designs from the past can look dated as we look back at them, at the time when they were new they often used the latest up-to-date techniques.

Here is a strong response to the same question:

 I think the packaging for Tekken 4 is a very successful graphic design. The Playstation 2 name and logo are clear at the top in order for people to see which platform the game is for. **(1 mark)** The use of technology is evident throughout the product. Even though the game came out in 1997 the designers must have used software such as Photoshop to achieve such a sleek finish. **(1 mark)** The imagery is dark, mysterious and threatening and the bolts of lightning create eye-catching highlights that grab your attention and communicate the excitement of the game. **(1 mark)** As this is Tekken 4 it is safe to say that Tekken 1, 2 and 3 were successful and this is being marketed to an existing market. **(1 mark)** The target market is probably teenage boys as they are the main users of Playstations. **(1 mark)** Also the imagery is all male and the tag-line mentions that the legendary battle begins. Most battle-themed games are aimed at boys, but quite cleverly on the back panel they have included images of female fighters too to attract female purchasers **(1 mark)** The use of text and lettering to create the Tekken 4 logo is also very strong as it uses a fiery orangey-red against an icy-cold background. **(1 mark)** The solid-looking silhouetted main figure stands strong in the centre. We cannot see his face and this communicates that it might be the person buying the game who can be the main character when playing the game; this is a very clever

form of marketing. **(1 mark)** My opinion is that this graphic design still looks eye-catching and interesting even though it's 11 years old. The skilful use of Photoshop has combined image and text together and communicates an exciting and dark atmosphere. **(1 mark)**

This answer reads very well; it follows the structure of the question, and it shows understanding of design issues, especially target market:

The solid-looking silhouetted main figure stands strong in the centre; we cannot see his face and this communicates that it might be the person buying the game who can be the main character when playing the game; this is a very clever form of marketing.

In fact this sentence might even get 2 marks, leading to the whole question getting full marks as it is such a well-described and interesting point. Using vocabulary such as **technology, imagery, tag-line, logo, silhouetted, marketing** and **communicates** all show that this person has a full understanding of the design issues that graphic design is concerned with.

Exam Example 6: Question 8 part (a) Product Design

This example shows you how marks are awarded to a good answer.

LEGO – Plastic construction toy, designed by Ole Kirle and Godtfred Christiansen (1958). Interlocking building bricks.

8. **Product Design**

(a) What important design issues, do you think, were considered in the development of this product? Why do you think it is still a successful toy today?

(SQA Higher Art and Design Past Paper, 2010)

Like all part **(a)** design questions, this assumes you have an understanding of **design issues** relating to product design, e.g. materials, aesthetics, ergonomics, target market, cost and manufacture.

Firstly, we should break the question into parts:

- **Design issues**
- **Product development**
- **Successful today**

Here is a good answer to this question.

 I think there are a few important design issues that the designers had to consider. They would have had to ensure that the blocks fitted together securely but were able to be pulled apart by young children. **(1 mark)** The colours of the blocks have been carefully considered in order to provide variety of choice and to let children be creative. **(1 mark)** Young children will be attracted to the bright, bold colours and big simple shapes. **(1 mark)** The material used, plastic, is very important. Plastic is a cheap material so this would keep manufacturing costs down but also you can mould plastic into many different and complicated shapes easily. **(1 mark)** Machines would be able to produce the plastic blocks and this would also keep costs down. **(1 mark)** The Lego blocks are strong so children cannot break them easily. **(1 mark)** They do not have sharp edges and younger children can use bigger Lego versions as they might swallow the smaller bricks. **(1 mark)** I think Lego is successful because you can use your imagination to build whatever you like. **(1 mark)** Also Lego has brought out lots of different versions like 'Star Wars' and 'Harry Potter' and this appeals to lots of people. **(1 mark)** Also, Lego has brought out technical sets that are quite complicated that appeal to older children and adults so they have a product that appeals to a wide target market. **(1 mark)** That is why this product has been successful for such a long time.

You can see where the person got the marks awarded. They mentioned materials, manufacture (machines), cost and target market. Remember, these design issues were not mentioned in the question but you need to know what they are and how to comment on them.

Another Example

This example shows you how marks are awarded to an answer that is just over the pass mark.

Here is a similar Product Design question to Exam Example 5, from 2008, that asks you to comment on an old piece of design.

Gramophone
This early music system is operated by a clockwork mechanism
which requires the user to wind up the handle.

8. Product Design

(a) What do you think the designer considered were important issues when designing this product? How does this gramophone compare with today's music systems?

(SQA Higher Art and Design Past Paper, 2009)

Here is an answer to this question.

Important issues they would have considered were: the target audience, ergonomics, style, function, key components, materials. (**1 mark**) Would this gramophone do what it is supposed to do, that is play music? The gramophone's materials are metal with wood, a gold copperish metal and dark wood, would that be pleasing to the eye? (**1 mark**) Would the product be easy to assemble and make, the materials widely produced, cheap or expensive? (**1 mark**) What type of people would want a gramophone, high class or low class? (**1 mark**) Would the gramophone be easy to use? Could you turn the handle easily or would it be hard? Could the pattern on the wooden box be more stylish? (**1 mark**) The gramophone compared with today's music systems is more old-fashioned and doesn't look very sleek and stylish, it is manual not electronic and can only play records. (**1 mark**)

This is a curious answer. On the face of it the answer seems to answer the question: *What do you think the designer considered?* However, the answer is really a list of possible considerations and does not go on to comment on the points made. Some of the points made are quite right as design issues are mentioned – unfortunately there is no discussion or personal opinion coming through.

USING ART AND DESIGN VOCABULARY

When answering a question, use the **vocabulary** that is in the question in your answer and show you know what it means. The following question on jewellery is a good example to show how to use specific art and design vocabulary well:

Exam Example 8: Question 11 part (a) Jewellery Design

This example looks closer at how you can use the vocabulary in a question to boost the quality of your answer.

> **11. Jewellery Design**
>
> (*a*) Comment on this jewellery design in terms of the designer's use of materials, handling of form and the wearability of the piece. What are your views on the use of recycled materials to create jewellery?
>
> > (*SQA Higher Art and Design Past Paper, 2007*)

So you should first split the question into parts:

- **Materials**
- **Form and wearability**
- **Recycled/opinion**

Write your answer, using the vocabulary in the question in the order that the parts appear in the question. For example:

In terms of the designer's use of materials I think that …
The designer has used form very well in this piece as …
I think the piece is very wearable because …
I think that it is a good idea to make jewellery from recycled materials because …

This way of answering may seem a little obvious, but it will ensure you have a good structure to your answer.

 Look through past papers and read the questions. Check that you understand the vocabulary used.

Here is the same question again, this time with the image:

Another Life designed by Marie Asbjornsen (2003) from recycled aluminium cans and steel wire

11. Jewellery Design

(a) Comment on this jewellery design in terms of the designer's use of materials, handling of form and the wearability of the piece. What are your views on the use of recycled materials to create jewellery?

(SQA Higher Art and Design Past Paper, 2007)

Let's split it into chunks again:

- **Materials**
- **Form and wearability**
- **Recycled/opinion**

Look carefully at the following answer and see how it has been split into parts and how specific vocabulary has been used:

*In terms of the designer's use of materials, I think she has been very inventive in making something delicate and beautiful from what was old aluminium cans. (**1 mark**) I also think it is very environmentally aware of the designer to decide to use recycled materials. (**1 mark**) The designer has used form very well as the bracelet is made up of lots of inter-linking cube forms that make a complicated structure. (**1 mark**) I think this structure is very interesting to look at and is definitely eye-catching. (**1 mark**) The piece looks lightweight and comfortable to wear but I think it looks very fragile as aluminium is quite a soft, bendy metal and might break easily depending on what the person wearing it is doing. (**1 mark**) I think this would be very wearable at a fancy dinner or important event. I don't think it is very wearable for day-to-day activities as it would get damaged too easily. (**1 mark**) You would also need to wear a sleeveless dress or an outfit with short sleeves as it would catch and rip any sleeves on the end of the steel wires. (**1 mark**) I think that it is a good idea to make jewellery from recycled materials because it saves on the world's limited resources. (**1 mark**) Also it shows the designer's skill in taking something that is not worth very much (aluminium cans) and transforming them into something people would want to wear. (**1 mark**) It's also good to wear jewellery sometimes that's not made from expensive materials as you will wear it more often because you will not be afraid that you will lose it. (**1 mark**)*

This is an excellent answer which has a structure that follows the question's structure and it uses the same vocabulary as the question. The person writing the answer was also able to give their opinion and back it up with fact. For example:

The piece looks lightweight and comfortable to wear but I think it looks very fragile as aluminium is quite a soft, bendy metal and might break easily depending on what the person wearing it is doing.

This kind of sentence is vital if you are to get a good mark. You must **comment**.

The answer also shows an understanding of the vocabulary in the question:

The designer has used form very well as the bracelet is made up of lots of inter-linking cube forms that make a complicated structure.

This shows a clear understanding of the use of the visual element of form.

PART (a) QUESTION REVISION

Hopefully, you can now see how to apply the tips on how to answer the part **(a)** question in the exam:

- Spend **15 minutes** on a part **(a)** question.
- Understand and refer to the **visual elements**.
- Understand and refer to **design issues**.
- Comment and discuss – **never just describe**.
- Break the question down into **parts**.
- Use the **vocabulary** that is in the question.
- **Justify** your opinions
- Read over your answer and count how many justified points you have made. **You won't get 10 marks unless you say at least 10 things.**

Remember, you cannot memorise facts in order to answer a part **(a)** well. You have to be **flexible** in applying your critical skills. Following the eight tips above should allow you to present your answers in the best possible way.

There are 12 part **(a)** questions in the exam – but you only need to answer two, one from Art Studies and one from Design Studies. You will never know what the question will be specifically about before the exam, so try to practise using past papers, following the eight tips above.

During the exam, try to stay calm. Read the question carefully. Read carefully the statement under the image. Double-check you are answering the correct question!

The question is not designed to *trick* you; it's an opportunity for you to demonstrate all your critical skills and apply them to a specific example.

HIGHER ART AND DESIGN PAPER 2 PART (b) QUESTIONS

The part **(b)** of any question is there for you to demonstrate your knowledge and understanding of artists and designers and their working methods. You should also show your critical skills by analysing, discussing, commenting upon and evaluating their work by referring to specific examples of art and design objects.

HOW TO ANSWER A PART (b) QUESTION

There are many ways of improving your skills in answering part **(b)** questions.

You should have studied the work of at least two artists or designers from **different art or design movements or periods in time.**

These artists or designers should have been active sometime from **1750** to the present day, not from any earlier date.

You need to be able to write about specific artworks and designs in detail. Remember – this question is about their **work** and their **working methods. The question is not about their lives.**

Plan to spend around **30 minutes on each part (b) question.** This includes time for reading the question and time to check what you have written. You will need to work quickly.

A part **(b)** question is always worth 20 marks at Higher level.

To answer a question **(b)** well requires lots of preparation. There is no way to avoid studying and learning about your chosen artists and designers. Your teacher should advise you which artists' and designers' work is appropriate to study.

 Part **(b)** questions require you to have learned about artists and designers. In many cases this involves memorising information. Do not merely write down what you remember without reading the question. You have to be flexible with your information in order to fit the question.

The easiest way to boost your grade is to make sure you answer the whole question. You will not get top marks if you do not answer all parts of the question.

Below are some examples of part **(b)** questions in **Art Studies** from SQA past papers.

3. **Still Life**

(*b*) Referring to examples of still life by **two** artists from different movements or periods, explain why you consider the works to be successful. How important are the artists in the development of still life? Discuss your answer.

(SQA Higher Art and Design Past Paper, 2007)

4. **Natural Environment**

(*b*) Select **two** artists from different movements or periods whose works respond to the natural environment. Discuss what each artist has communicated to you about the environment. Comment on their choice of subject matter and their working methods. Why are they considered to be important artists?

(SQA Higher Art and Design Past Paper, 2005)

6. **Fantasy and Imagination**

(*b*) Compare examples of work by **two** important artists from different movements or periods. Discuss the methods used by the artists to communicate their ideas on the theme of fantasy and imagination. Explain why you consider the examples to be typical of the artists' styles.

(SQA Higher Art and Design Past Paper, 2004)

Below are some part **(b)** questions in **Design Studies** from SQA past papers.

12. **Textile/Fashion Design**

(*b*) Choose **two** fashion/textile designers whose styles are contrasting or who work in different periods. With reference to specific examples of their work, show how their distinctive approach to design has made them important and influential.

(SQA Higher Art and Design Past Paper, 2005)

7. Graphic Design

(*b*) Choose **two** graphic designers working in different periods or styles and compare their methods of visual communication. Identify key aspects of their work and state why they are regarded as important designers.

(SQA Higher Art and Design Past Paper, 2006)

You should see an obvious pattern: The questions usually have **3 parts**.

- Write about two artists or designers.
- Write about aspects of their work or working methods.
- Write about why they are important or influential.

As with part **(a)** questions you have to refer to visual elements, artists' and designers' techniques and working methods, design issues and **specific examples** of their work.

However, occasionally part **(b)** questions can have a slightly different structure. Look at this question from the **2009** paper:

8. Product Design

(*b*) A successful product

"has simplicity and quality, does what is demanded of it, is economical to use, easy to maintain ... It also sells best and looks good".

Select **two** designers working in different periods or styles and discuss this statement, or any part of it, in relation to their work. Why are they important designers?

(SQA Higher Art and Design Past Paper, 2009)

This question looks different because of the quotation; however, it actually provides a list of design issues for you to follow in your answer:

- simplicity and quality
- fitness for purpose
- economics
- maintenance
- market
- aesthetics

The question asks you to discuss the statement or **any part of it.** So you actually have the freedom to pick and choose the design issues you are most comfortable with.

As long as you have prepared thoroughly, studied and focused on the artists' and designers' **work, working methods and design issues**, you will be able to answer any question. Be **flexible** with your information to fit the question.

HOW MARKS ARE ALLOCATED FOR PART (b) QUESTIONS

At Higher level, part **(b)** questions are always marked out of 20. Roughly speaking, that means 8 marks on each artist or designer and 4 marks for the final part of the question. Aim to say eight justified points about each artist's or designer's work that are relevant to the question.

If you only discuss one artist or designer, the maximum mark is 10 out of 20.

If one of your artists' or designers' works is from before 1750, then the maximum you could get is 14 out of 20.

If you write about two artists or designers, but they are from the same movement or style the maximum is 14 out of 20.

If you write only about the artists' or designers' lives with no or minimal discussion of their work, the maximum you can achieve is 8 out of 20.

Exam Example 9

This example shows the importance of keeping historical and biographical details brief. You will not get many marks for writing lots on the artists' lives. Keep the biography short; for example:

Vincent Willem Van Gogh (1853–1890) was born in Holland but spent his most productive years in France. He is an incredibly well known and talented artist who developed his ideas from the Impressionists, who were famous for their bright colours and depicting normal everyday life. Van Gogh used specific Impressionist techniques and developed his own style to portray strong emotion. He often used raw pigments and strong colours; his work is usually recognised by his strong, vigorous brush strokes. These elements can be seen in 'Self- Portrait with Bandaged Ear' (1889).

This is an excellent introduction to a part **(b)** – the answer does not go into Van Gogh's life story (everyone has heard the ear story anyway!). Importantly, it discusses Van Gogh's influences (the Impressionists) and how he began to develop his own style.

Read the next example and compare it to the first:

Vincent Van Gogh was born in the small town of Groot-Zundert in Holland. His father was a preacher and originally Vincent tried to follow in his father's footsteps – but was not very successful. Vincent had mental health problems which made him have mood swings; he could be very excited one minute and then very depressed. He famously cut off his ear after an argument

and gave it to a woman. Van Gogh saw the work of the Impressionists. He died sadly in 1890 after shooting himself with a rifle in a corn field. The painting I am writing about is called 'Self-Portrait with Bandaged Ear'.

The second example has far too much biographical information and does not expand on the important parts, for example the effect the Impressionists had on Van Gogh.

HOW TO STRUCTURE YOUR PART (b) ANSWER

It is important to structure your answer properly.

Try to answer the points of the part **(b)** question in the order that they appear in the question. It can be easier for the marker to know you have answered the final part of the question if you leave that until the end of your answer.

Remember, the final part of the question is worth 4 marks. If you do not answer it you will only be marked out of a maximum of 16.

Look at the highlighted final part in the two questions below.

> 7. **Graphic Design**
>
> (*b*) Select **two** graphic designers whose work is from different periods or in different styles. With reference to examples, identify the main design issues in their work.
> **Explain why they are considered to be important graphic designers.**
>
> *(SQA Higher Art and Design Past Paper, 2009)*

> 2. **Figure Composition**
>
> (*b*) Compare examples of figure composition by **two** artists from different movements or periods. Discuss the methods used by the artists to communicate their ideas.
> **Explain why the artists are considered to be important contributors to the art of figure composition.**
>
> *(SQA Higher Art and Design Past Paper, 2004)*

> Make sure you answer the final part of the question. In some ways the final part of the question is the easiest 4 marks in the paper. However this is only true if you have prepared.

Look at the following excerpts from an answer that tackles the final part of a question **(b)**:

Both Van Gogh and Picasso are considered important and influential in the development of portraiture. Van Gogh developed further the techniques of the Impressionists by bringing an emotional depth to his work. He greatly influenced the work of the Expressionists such as Klimt and Kirchner, who developed his exaggerated colours and swirling backgrounds. Picasso, through Cubism, brought the 3D world into 2D painting, and Synthetic Cubism, using collage, brought sculpture and painting together. He also inspired artists such as David Hockney, who has taken Picasso's ideas and used them in portraits in paint and using photographs.

This is a very strong response to the final section of a part **(b)** question as it clearly addresses both artists dealt with and, importantly, names specific artists who were inspired by them and how they were inspired.

Ensure you make at least four justified statements and give specific examples for the final part of your answer. This is a good way to maximise your allocation of marks.

Exam Example 10: Question 1 part (b) Portraiture

This example looks at an excellent response to a part **(b)** portraiture question.

1. **Portraiture**

(*b*) Compare examples of work by **two** artists from different movements or periods whose approaches to portraiture are contrasting. Comment on their working methods, styles and subjects.

(SQA Higher Art and Design Past Paper, 2002)

Two artists who have different working methods and styles within portraiture are Vincent Van Gogh, who was part of the Post-Impressionist group of artists, and Pablo Picasso, who created the Cubism movement with Georges Braque.

Vincent Van Gogh (1853–1890) is an incredibly well-known and talented artist who developed the tradition of the Impressionists, who were famous for their use of bright colour and depicting normal everyday life. **(1 mark)** Van Gogh used specific Impressionist techniques such as using complementary colours, and applied these to his own paintings, but he developed his own exaggerated use of colour and intensity of vision. **(1 mark)** His painting 'Self-Portrait with Bandaged Ear' (1889) sees Van Gogh use the intensity of his personal emotions and depict this in his painting. He portrays himself as a man very much in pain both mentally and physically and is evidently in a depressive state at this time. **(1 mark)** He uses the warming tones of yellow when depicting the face; this gives a sickly look that contrasts with the blues and purples in his overcoat. His face has an intense and stern look. However, due to the bright whites of the bandage, it is clear that he wanted to highlight the painful infliction he placed upon himself. **(1 mark)** He also uses contrasting colours of blue and orange and reds and greens which represent the variety of emotions surrounding him and the conflicting feelings he has. This creates a very dramatic effect in terms of use of colour. **(1 mark)** The rough, vigorous brush strokes on the jacket contrast greatly with the gentle brush strokes used to portray the fluffiness of the hat. **(1 mark)** The unrealistic colours used throughout also show how Van Gogh was influenced by Japanese art. Van Gogh was inspired by Japanese art's bold colours and flattened perspective, which can be seen in this self-portrait too. The depiction of a Japanese print in the painting also reveals this. **(1 mark)** Van Gogh is determined to reveal his emotional state as he stares out blankly at you with such a horrendous wound. He must have been at a very low point to self-harm in such a way but to then decide to paint a self-portrait reveals a dedication to his work. **(1 mark)** Often Van Gogh painted ordinary people who lived near him, as he could not afford a model and he had no commissions. When there was no one else he would paint himself. He then tried to depict his inner thoughts and feelings on the surface of his canvas. **(1 mark)** This approach to portraiture influenced the pioneers of Expressionism like Klimt, Kandinsky and Schiele, and his vivid use of colour inspired the Fauves. **(1 mark)**

Pablo Picasso (1881–1973) is famous for many different styles of art but perhaps is most well known for inventing Cubism with Georges Braque. Cubism developed the ideas of Paul Cézanne, who believed the world could be broken down to cubes, spheres and cylinders. **(1 mark)** Cézanne also experimented with showing more than one viewpoint at a time in his paintings. This idea influenced Picasso a great deal. The movement was separated into two styles: Analytical Cubism (1909–1912) and Synthetic Cubism (1912–1919). **(1 mark)** Analytical Cubism is known for its monochromatic colour scheme and its intellectual approach to expressing the 3D world using geometric lines and angular shapes. The 'Portrait of Ambrose Vollard' was painted in 1910 and shows the figure of the famous art dealer Vollard. **(1 mark)** It is clear Picasso may have been inspired to paint Vollard not only because he was his art dealer but because Paul Cézanne had depicted a similar posed portrait many

years previously. However, I think Picasso did this in order to develop his knowledge and create a 3D effect upon a 2D canvas. **(1 mark)** The figure of Vollard merges in with the fragmented background in places almost as if both were part of the same thing. Picasso has used lighter golden tones when depicting the head of Vollard and so this the only part clearly recognisable in the painting. This therefore makes it the focal point. **(1 mark)** The background has simply been made using darker tones and therefore contrasts with the face. Vollard has been shown with a very stern and concentrated look on his face and portrays the idea of intense thought or meditation. **(1 mark)** Picasso has also applied his paint in thin layers, using short, gentle, controlled brush strokes in different small areas, resulting in a many-faceted surface. **(1 mark)** Through his monochromatic colour scheme and geometric lines, Picasso is able to give the illusion of depths in the painting like shattered glass. **(1 mark)** Picasso has been able to inspire many people through his art. He particularly inspired British artist David Hockney, who now uses the idea of multiple viewpoints in his own paintings and photo-collages. **(1 mark)** Picasso led other artists to experiment with representing the 3-dimensional world in 2D painting, leading to collage and experiments with sculpture.

Both artists show some similarities in that both have captured stern and powerful expressions. This is due to Van Gogh's use of bold colour and Picasso's deliberate and concentrated lines. Van Gogh's art depicts a wild, intense emotional journey that shows his internal state of mind. Picasso shows us a scientific experiment where he is playing with the way reality can be represented in 2D. **(1 mark)**

This example is easily 20 out of 20, in fact there are more than 20 justified points made – but 20 is the maximum that can be awarded!

Exam Example 11: Question 1 part (b) Portraiture

Here is a weaker answer to the same question, using the same artists:

Two artists from different movements are Vincent Van Gogh and Pablo Picasso. Vincent Van Gogh died in 1890 and expressed his art with thoughts and feelings. He used rhythmic and harsh brush strokes as well as exaggerated colour. **(1 mark)** Many artists were inspired by him and his own tragic story as well as him showing his inner thoughts and torments. The thick brush strokes that he used would show how he was feeling at the time and he put his emotions into his work. **(1 mark)** 'Self-Portrait with Bandaged Ear' was one of his greatest pieces. Thick harsh brush strokes of yellow are on his face. Dark brush strokes are on his coat. **(1 mark)**

Pablo Picasso was considered the most famous artist of the 20th century. He was also interested in sculpture, ceramics and printmaking. He wanted to bring sculpture and painting together. **(1 mark)** Picasso would make paintings of different

viewpoints all together. He inspired artists to continue his Cubist ideas even further. **(1 mark)** Picasso did a portrait of Ambrose Vollard which is a typical piece of Cubist. Monochromatic colours have been used and it looks like you are looking at lots of cubes. You can recognise the face with its pale pink. **(1 mark)** Vollard looks like he is thinking about something and the background is dark and gives the impression he is sitting in a corner of the room. **(1 mark)**

Both these artists are considered important because they inspired other artists. Van Gogh inspired other artists to show their feelings where Picasso encourages them to continue to develop the idea of Cubism.

This answer got 7 out of 20. It shows a basic understanding of some aspects of the artists' work, but fails to comment or discuss in detail. Remember the question asked: *Comment on their working methods, styles and subjects.* The key word here is comment – this means to give a personal view backed up with reasons. Also, the answer above is just too short. There is a failure to show a real understanding of Cubism or Post-Impressionism. Some sentences are just short descriptions and are not comments:

Monochromatic colours have been used and it looks like you are looking at lots of cubes.

There is no mark awarded for this sentence as it does not comment on the effect of the monochromatic colour or discuss the cubes.

Exam Example 12: Question 3 part (b) Still Life

This example is of a poor still life part **(b)** response. This answer shows the need for preparation and knowledge of your chosen artists' work and working methods.

3. **Still Life**

(b) Discuss still lifes by **two** artists from different periods or movements. Focus on their style, use of composition and media handling. Comment on these artists' contributions to the development of still life.

(SQA Higher Art and Design Past Paper, 2010)

Jack Morrocco was born in 1953, in Edinburgh. He studied art at Duncan of Jordanstone college in Dundee. He lived there from 1970 to 1974. He found his life hard to live as he lived by himself. **(1 mark)** Then he began to set up a business and it made a lot of money. In 1997 he decided to paint full time in his studio, which was in his house. He also had two other houses, one in the South of

France and one in Fife. He now gets all his money from his paintings. He also did three types of painting which were still life, landscape and figures. **(1 mark)** It's very difficult being good at all three of them, which again tells us he is a very talented man.

Samuel Peploe was born in 1871 in Edinburgh, the capital of Scotland. He died in 1935 at the age of 63. Peploe did well in school. He went to a private school because he was from a wealthy family. He also had supportive parents, which helped him even more. **(1 mark)** In 1893 he went to Edinburgh school of Art. He also studied in Paris. In 1903 he had his first one-man show and became very popular. **(1 mark)**

Morrocco started painting at a young age and Peploe started a little later. They were both from Edinburgh. Jack mostly paints instruments and sometimes fruit, but Peploe uses fruit a lot in his paintings. **(1 mark)** Morrocco always uses objects in his paintings and mostly uses warm colours such as red, orange and pink. Peploe mostly uses cold colours such as blue, green and purple. Sometimes the same objects are used in both their paintings. I like the way that Morrocco has painted his pictures because it looks more neat and clear. Whereas Peploe's painting is not very clear and has a smudged effect. From the painting between Peploe and Morrocco I would say that I like Morrocco's painting the most. **(1 mark)**

As you can see, this answer does not pass and was marked at 6 out of 20. This answer ignores almost all the points in the question. There is no discussion of the artists' working methods, their use of composition and media. The statements made are very basic and do not go into any detail. There is also too much basic biographical information, considering the short length of the whole answer. It is almost as though the person writing the answer had not prepared or studied and was struggling to recall anything other than broad general points. Importantly, the following section is worth highlighting:

Morrocco always uses objects in his paintings and mostly uses warm colours such as red, orange and pink. Peploe mostly uses cold colours such as blue, green and purple.

The part about Morrocco using objects is so general it is meaningless and the statement about the artists' use of colour is in fact untrue – both artists use warm and cold colours. In this case a mark is not deducted – it is just not awarded.

Remember, markers are **awarding** marks – not deducting them.

Exam Example 13: Question 7 part (b) Graphic Design

This is a good example of a Graphic Design part **(b)** question. This answer shows why it is important to check how much you have written.

7. Graphic Design

(*b*) Select **two** graphic designers from different periods or whose styles are contrasting. With reference to specific examples of their work, explain how they communicate their ideas effectively to a wide audience. Why are they considered to be important graphic designers?

(SQA Higher Art and Design Past Paper, 2004)

The two graphic designers I will be writing about are Alfonse Mucha and Martin Sharp. Alfonse Mucha mainly produced designs for advertisements, cigarette companies, jewellery and theatres. **(1 mark)** He was so successful that he created his own style, the 'Mucha Style', and this became the main graphic theme for the Art Nouveau period. **(1 mark)**

Martin Sharp was known as Australia's most prominent pop artist. He mainly produced designs for musicians such as Bob Dylan and Jimi Hendrix. Sharp's brightly coloured designs fitted in well with the psychedelic era of the 1960s. **(1 mark)**

These two designers had very different styles of work. Alfonse Mucha's designs were very old-fashioned and appealed mainly to the upper-class. He used very dull, subdued colours in his graphics. This sometimes made the text difficult to read but it usually stood out enough to be understood. **(1 mark)** Mucha's designs usually featured a young, attractive, healthy woman wearing a long, flowing robe surrounded by flowers. This is a reason why his designs appealed to upper-class men. **(1 mark)** His designs were also usually long and tall, this gave a sense of elegance which is why his designs appeal to an upper-class market. **(1 mark)** An example of a successful design is 'Gismonda'. This features a woman standing upright surrounded by flowers advertising a theatre production. Women were not treated equally at the time of the Art Nouveau period which is why Mucha aimed his designs at men. **(1 mark)**

Martin Sharp has extremely different ideas and style from Mucha. Sharp's designs were always brightly coloured and eye-catching and were influenced by optical-art. **(1 mark)** The text in Sharp's designs was mainly white and rounded. This made it stand out from the rest of the bright colours and also appeal to people in the 1960s. **(1 mark)** Sharp's graphics could be seen as being slightly abstract as one image was usually made up of several different objects together. An example of this would be his posters 'Bob Dylan' and 'Explosion Jimi Hendrix' were both slightly abstract. **(1 mark)**

The target market for Sharp's designs would be teenagers or young adults who had an interest in popular music. Therefore his designs were aimed at a wide audience. His work would appeal to them due to the bright swirling colours and the fact that they were obviously linked to music. **(1 mark)** Mucha's designs were aimed at men, who were the main audience for adverts for cigarettes and it was usually men who made most of the decisions on spending money in the 1890s–1910s. **(1 mark)** In my opinion Sharp's designs are most successful as they still look fresh and appealing today. **(1 mark)** Sharp's designs look as modern as other graphics that are made today using computers, but Sharp made his by hand. **(1 mark)** Although Mucha's designs were successful during the Art Nouveau period they are not as successful now due to their dull colours and association with unhealthy products such as tobacco and cigarettes. **(1 mark)**

This answer was graded at 15 out of 20. There are some very good points and the answer reads very well. The answer is just a little too short. More comment and discussion on the specific designs would have helped. Also the final part of the question: *Why are they considered to be important graphic designers?* is not really answered. Remember, there are 4 marks allocated to just this last part.

> Remember to check you have answered the final part of the question and have commented on at least 20 things.

Exam Example 14: Question 8 part (b) Product Design

This example shows why it is important to refer to design issues in your answer. It also shows the need for detailed information on your chosen designers' work and working methods.

> ### 8. Product Design
> (b) Select **two** designers or groups of designers working in different periods or styles. With reference to particular designs, discuss some of their most important ideas and approaches to the designing of products.
>
> *(SQA Higher Art and Design Past Paper, 2002)*

Two product designers from different periods are Louis Comfort Tiffany and Philippe Starck. Tiffany was famed for creating elegant, stained glass products. **(1 mark)** He showed the world new ways to combine glass using thin strips of bronze. **(1 mark)** Glass and bronze were nearly always used in Tiffany's work. One such example of his work is the 'Peony Lamp' which was

constructed from bright and colourful glass shards intertwined with bronze to hold it all together. **(1 mark)** Tiffany is famed as a designer as he worked for many famous clients. These included creating an entire room within the White House and a set of windows for the Four Seasons Hotel. **(1 mark)** He was also one of the first designers to incorporate electrical bulbs into lighting designs, an idea that changed the lighting industry forever. **(1 mark)**

Philippe Starck, although born into a completely different world from Tiffany, was just as important as an artistic pioneer. He is famous for using 'space-age' materials such as opaque plastics and chrome. **(1 mark)** His futuristic designs are all mass-produced and sold at cheap prices, unlike Tiffany's work which was all constructed by hand and sold at exceedingly high prices. **(1 mark)** Starck is also one of the most versatile designers ever seen, ranging from designs for orange squeezers to motorbikes. **(1 mark)** One of his most celebrated creations was the 'Miss Sissi' table lamp. The lamp was made from a very small amount of opaque plastic and came in a wide range of colours. **(1 mark)**

Tiffany is considered important as his designs were the most elegant and unique during his time. Starck is considered important because he showed the world that appealing design could be mass-produced and beneficial to everyone. **(1 mark)**

This answer was awarded 10 out of 20. It shows a general understanding of the two designers and mentions examples of their work. There is, however, very little detail. With regard to Tiffany, there is no mention of the design movement Art Nouveau – in fact there are no dates mentioned at all. There is no understanding shown of what are the *different periods* mentioned. The answer makes some good, valid points but generally there is not enough information (it is too short).

Exam Example 15: Question 8 part (b) Product Design
This example is a very good answer to the same question as Example 14. Compare the two closely and see where the marks were awarded.

 The designers of the Art Nouveau movement and the Bauhaus design school had two different approaches to product design. Louis Comfort Tiffany (1848 – 1933) was an American craftsman working in glass and metal during the Art Nouveau period (1880 – 1910). Art Nouveau is the term given to the design movement which began in Europe and then spread to America. **(1 mark)** The Art Nouveau designers were very influenced by natural forms and produced elongated, flowing lines in lighting, furniture, architecture, jewellery and other design forms. The work is typified by the whiplash line and non-geometric forms based on animal and plants. **(1 mark)** Carl J. Jucker and Wilhelm Wagenfeld were two designers working at the German Bauhaus school of design. The Bauhaus philosophy was 'less is more' and the designers there created a machine aesthetic which meant their products had a simplified, functional and often geometric look. **(1 mark)**

Louis Comfort Tiffany was, in his day, America's leading glass-smith. As a way of using the off-cuts from the company's stained-glass windows Tiffany created the Tiffany Lamp around 1910. **(1 mark)** The lamp has a stained-glass shade which is supported by a lead base. As an Art Nouveau designer, Tiffany rejected the use of the straight line and right angle and favoured a more graceful and flowing form. **(1 mark)** The large lead base is bulbous and was originally designed to store oil inside the base to power the light. **(1 mark)** Later versions were designed to work with electricity and the power flex fed into the bottom of the base. The base was sculpted to resemble a plant form like the trunk of a tree. **(1 mark)** The Tiffany Lamp was laboriously hand-made – so it was never manufactured in huge numbers on a factory line – and therefore was very expensive to buy. **(1 mark)** The individual coloured glass pieces were carefully soldered together with lead piping, creating a network of colours like a butterfly wing in a dome shape over the base. When lit the lamp emitted a soft warm glow with reflected coloured lights. **(1 mark)** The materials used to create the lamp were expensive; many designers experimented with new and unusual materials such as metals like lead, bronze and silver. Tiffany was always looking for new ways of producing and crafting glass products that were transparent, coloured or semi-transparent – he even invented his own glass, Favrile Glass. Favrile glass is a type of semi-transparent, coloured glass created by Tiffany. **(1 mark)** It was patented in 1894 and first produced in 1896. It is different from other coloured glass as the colour is part of the glass and not added later. Favrile glass was used in Tiffany's stained-glass work and the offs-cut used in his lamps. His lamps soon became highly desirable because not only were they works of handcrafted beauty that looked good even as decorations in the home but because they provided such elegant and beautiful light.

The Bauhaus Table Lamp was designed between 1923 and 1924. It follows the famous school of design's rules regarding the design issues of form and function as it is a very simple and minimal design made of glass, opalescent glass, steel and brass. **(1 mark)** The idea of the spherical shade came from an existing light shade used in factory lighting. **(1 mark)** It was not decorative at all. A steel tube inside a glass tube hid the wires and a brass rim went around the opalescent globe shade. **(1 mark)** The Bauhaus designers Jucker and Wagenfeld were interested in stripping down products to their simplest forms. **(1 mark)** It was for this reason that the idea of 'form follows function' came about – they believed that there should not be anything additional or purely aesthetic about a product and that every part should have a function. **(1 mark)** The function of the object was the most important part and the beauty of the object came from its simplicity. Even today the Bauhaus Table Lamp looks contemporary. The Bauhaus designers did not restrict themselves just to lighting but also designed most domestic products as well as architecture and interiors – this helped them see how materials and objects could be used in a variety of ways. **(1 mark)** Essentially the Bauhaus designers Jucker and Wagenfeld pared down the shapes and forms of the Art Nouveau period and discarded any form of

decoration. It has to be said that these two forms of table lamp; the Tiffany Lamp and the Bauhaus Lamp, designed less than fifteen years apart, are very different in approach and manufacture. **(1 mark)** The Bauhaus designers also pioneered the use of steel tubing and rubber fittings that are still in use today. Their idea was that the Table Lamp would be cheap and easy to produce on a production line and be available to the widest group of people. This was never the case however, due to the manual labour that was needed to produce the desired effect. **(1 mark)** The Tiffany Lamp used expensive techniques and materials and being hand made was only affordable by the very wealthy. **(1 mark)** On this point, expense to manufacture, the Tiffany Lamp and the Bauhaus Lamp share the same design problem. **(1 mark)**

This answer got 20 out of 20. You can probably see that even more marks could have been awarded to the section on Tiffany (if this was possible!) as it is very detailed and full of interesting comments, but 20 is the maximum marks that can be awarded. You may also note that back in 2002 the structure of question part **(b)** was slightly different and did not always include the *'explain why your chosen designers are influential'* part. But remember, part **(b)** questions now normally contain this important part.

Exam Example 16: Question 11 part (b) Jewellery Design

This example from the **2010 SQA** paper shows a good answer and also the importance of answering the final part fully.

> **11. Jewellery Design**
>
> (b) Select **two** designers working in different periods or whose approaches to design are different. With reference to examples of their work, discuss their influences, working methods and styles. Why are they recognised for their contributions to jewellery design?
>
> *(SQA Higher Art and Design Past Paper, 2010)*

I have been studying the work of two very different jewellery designers: René Lalique and Peter Chang, who worked during different time periods but who proved that jewellery has simply been a development from earlier work completed years ago.

Art Nouveau was prominent between 1880 and 1910, first in Britain and Europe and then in America, where the movement really took off. René Lalique was recognised as one of France's foremost Art Nouveau jewellery designers. **(1 mark)** He would use all types of materials to produce different effects. He used different colours and

stones to produce work of enormous variety, shape and form. **(1 mark)** An example of his work which demonstrates his unique usage of colour and materials is the 'Bird Ring Gold Enamel Peridot' completed in 1904. **(1 mark)** This was an engagement ring so would have been worn by, I believe, a rich, upper-class lady on the engagement finger or by others to simply decorate the hand or match another piece of jewellery or outfit. **(1 mark)** The ring is mainly gold which again verifies that this would have been an expensive ring. On the ring are two turquoise symmetrical birds whose heads are outlined with smooth enamel that forms the best part of the ring. **(1 mark)** The cushion-shaped peridot complements the birds as it is a slightly more subtle shade of green. The colours and the birds reflect Lalique's inspiration, which very often came from nature and organic substances. **(1 mark)** The smooth gold line is continuous throughout the full ring; it flows and again highlights how intricate and expensive the ring would be. **(1 mark)** Ergonomically I think that this would work well as a ring as it would have been attractive and different back in the early 1900s. However, although the basic ring shape would not cause huge discomfort, I think that the birds could be jaggy and get caught easily so maybe this ring is not practical for everyday wear. **(1 mark)** Lalique is recognised for his contributions to jewellery design as he would use any materials necessary to produce his effect, virtually anything his fantasy would suggest. He was innovative and was not afraid to break from the traditional rules of design. **(1 mark)**

A contemporary designer I chose to study is the British sculptor and jewellery designer Peter Chang. Chang works exclusively in acrylic to create unusual objects and often incorporates found objects into his oversized pieces. **(1 mark)** An example of his work is 'The Ring 2009' which is on display at the Scottish Gallery. I chose the ring as it is eye-catching because of its bright colours and its unusual shape creates a unique sense of fun. **(1 mark)** The function of this ring would be to decorate the hand or match another piece of jewellery or outfit. **(1 mark)** The ring consists of almost a helmet shape with on it further shapes filled with bursts of colour. It is made from PVC and acrylic with bursts of blue, pink, yellow, green and black which are all over the ring in different shapes and patterns. **(1 mark)** The unusual shape and the rough texture to the ring suggest to me that Chang based this ring on shells. **(1 mark)** Like Lalique his inspiration often comes from nature as well as good and evil, which reflects his use of unusual combinations of colour. **(1 mark)** I think the target audience for this ring would be women in their twenties who are interested in fashion as the ring is fun, young, bright and lively. **(1 mark)** Chang is recognised as he forms his jewellery in semi-organic structures so that they rest themselves or curl around the body comfortably. Therefore he too is not afraid to experiment and change the shape of his jewellery to make it more comfortable for people to wear. **(1 mark)** The ring would ergonomically work well because of how neatly it sits on the finger but again, as it is so large and overpowering, it may not be suitable for everyday wear. **(1 mark)**

This answer is marked at 18 out of 20. It is a good answer that is full of personal opinion and good discussion of the designers' work. Importantly, the answer refers to the relevant design issues throughout, such as materials, form, target market, ergonomics and form. Sources of inspiration are also mentioned.

Why did it not get full marks? Although it is a good answer, it does not fully answer the final part of the question: *Why are they recognised for their contributions to jewellery design?* The part of the answer on Chang's contribution to jewellery design repeats itself a little and requires more information:

Chang is recognised as he forms his jewellery in semi-organic structures so that they rest themselves or curl around the body comfortably. Therefore he too is not afraid to experiment and change the shape of his jewellery to make it more comfortable for people to wear.

The part of the answer on Lalique's contribution to jewellery design again lacks specific details on which materials he used and how he used them. It also does not explain how he specifically broke the 'rules of design':

Lalique is recognised for his contributions to jewellery design as he would use any materials necessary to produce his effect, virtually anything his fantasy would suggest. He was innovative and was not afraid to break from the traditional rules of design.

If these parts had been answered more specifically, the answer would then have been awarded full marks as not only would the final part of the question have been answered, but also the part about *working methods*.

Exam Example 17: Question 12 part (b) Textile/ Fashion Design

This example is a good answer to a Textile Design part **(b)**.

12. Textile Design

(*b*) Fashion and textile designers are required to produce ideas for different target markets. Select **two** fashion/textile designers working in different periods or styles. Show, with reference to examples of their work, how they have responded to this challenge. Why are they important designers?

(SQA Higher Art and Design Past Paper, 2003)

 Two extremely important and influential designers that have influenced the fashion world are Christian Dior (1905-1957) and Vivienne Westwood, who was born in 1941. Christian Dior is well known for his feminine post-war style, whereas Westwood is recognised all over the world for her outrageous, extravagant and provocative designs. **(1 mark)** In 1947 Christian Dior had his first couture fashion show in Paris, where he introduced his famous outfit 'The Bar Suit'. This consisted of a jacket with rounded shoulders and nipped-in waist; it then went over the hips to portray a curvy feminine figure, which was very elegant. **(1 mark)** The jacket had a figure-hugging fitted look with a slim waist and padding at the hips to create an hour-glass figure. Dior wanted to introduce this feminine collection as he felt that by doing this people would have something positive to think about after the horrors of World War 2. **(1 mark)** He also hoped that by creating an elegant look, it would allow women to feel feminine again after wearing rationed clothing made from rougher fabrics during the war. Dior used fabrics such as silk, wool and tulle to create his style. **(1 mark)** This style was called the New Look but Dior originally called it the 'Corolle Collection' which means ring of petals, which again emphasises his inspiration of flowers and femininity. **(1 mark)** Dior used extensive amounts of fabric to create the skirt and the most expensive shantung for the jacket silk. This was initially frowned upon by the government as during the war many fabrics had to be rationed. **(1 mark)** This meant that Dior's target market was extremely wealthy women who would have Dior create haute couture New Look outfits costing thousands of pounds even in the 1940s and '50s. **(1 mark)** The 'Bar Suit', although very smart-looking and accessorised with long gloves and a hat, was quite impractical due to the amount of fabric used in the skirt. Women also found that the tulle which was used to give the skirt volume was sometimes quite uncomfortable and itchy. **(1 mark)** A decade after Dior's death the New Look silhouette had been adopted by many teenagers in Europe and America (with much cheaper fabrics) with tight waists and huge billowing skirts. **(1 mark)**

Vivienne Westwood is known as one of the most outrageous designers of all time due to the provocative nature of her work. Westwood opened a shop with her partner Malcolm McLaren in London called 'Let It Rock'. The clothes they sold were in the style of Teddy Boys and then McLaren persuaded Westwood to start making her own clothes. At this time Westwood used the cheapest of fabrics and printed on existing T-shirts as well. **(1 mark)** Westwood's early working methods involved ripping clothes and adding safety pins and sometimes offensive words and pictures. Years later Westwood's designs became more refined as she learned more about tailoring. **(1 mark)** In 1993 she produced the 'Bettina Jacket' as part of her Anglomania collection. This collection showed Westwood's love of traditional British fabrics such as wool, tartan and Harris Tweed. **(1 mark)** The Bettina Jacket took its inspiration from Dior's Bar Suit jacket as it has a nipped-in waist and curves over the hips to emphasise the woman's figure. **(1 mark)** The jacket is made from

Harris tweed woven into a tartan. However, it is bias cut, which means the tartan is diagonal rather than the traditional vertical and horizontal. Bias cutting wastes a lot of fabric but makes the fabric sit against the body better. **(1 mark)** This is one way that Westwood made this traditional-looking outfit seem more edgy. This jacket would have been very expensive as the fabric is woven by hand on the Isle of Harris and Isle of Lewis, and also because of the wastage due to bias cutting. **(1 mark)** The jacket is accessorised by a hat with a large pheasant's feather which links the look to royalty and hunting. **(1 mark)** Christian Dior has become a very influential designer as he encouraged women to feel feminine again after the war. He also introduced the idea of creating a 'look' with accessories such as matching hats and gloves. **(1 mark)** His look was copied all over the world and can be seen in the Rock and Roll look of American girls in the 1950s as well as the accessorised suits their mothers would wear. **(1 mark)** Vivienne Westwood is an important designer as she inspired people to make their own outfits through her early do-it-yourself punk outfits that used cheap materials and simple techniques. **(1 mark)** Also she made people interested in traditional British fabrics again. Westwood's outrageous approach has influenced John Galliano and Alexander McQueen, who took her unconventional approach even further. **(1 mark)**

This example is very well written and got 20 out of 20. Note that there is not much biographical information and the answer concentrates on the designers' work and working methods. There are references to design issues, using specific examples, and the final part of the question is answered very fully, again with specific examples.

PART (b) QUESTION REVISION

Hopefully, you can now see how to apply the tips on how to answer the part **(b)** question in the exam. Here is a summary:

- Spend **30 minutes** on a part **(b)** question.
- Understand and refer to **the visual elements**.
- Understand and refer to **design issues**.
- Comment and discuss – **never just describe**.
- Break the question down into **parts**.
- Use the **vocabulary** that is in the question.
- **Justify** your opinions.
- **Remember to check you have answered the final part of the question – it's worth 4 marks.**
- Read over your answer and count how many justified points you have made. **You won't get 20 marks unless you make at least 20 points.**

Remember, you have to have memorised specific information about your chosen artists and designers. You have to refer to **specific works** they have made. You must know about their working methods. You also have to be **flexible** in applying your knowledge and critical skills. Following the nine tips above should allow you to present your answers in the best possible way.

There are 12 part **(b)** questions in the exam – but you only need to answer **two**, one from Art Studies and one from Design Studies. You should have a good idea of the kinds of things you will be asked about from talking to your teacher, looking at past papers and using this book. Try to practise using past papers, following the nine tips above. **Time yourself when you practise.**

During the exam, try to stay calm. Read the question carefully. Double-check you are answering the correct question!

The questions are not designed to *trick* you. They're an opportunity for you to demonstrate all your knowledge and critical skills and apply them to a specific question.

5 Glossary of art terms

Here is a list of the visual elements that you should be familiar with when discussing and describing artists' work.

Abstract: An image made of shapes, colours and textures making no recognisable picture. Non-figurative.

Aesthetics: How the painting or work of art appears to the viewer. Its general appearance in relation to beauty.

Atmosphere: The mood or feeling created by a work of art.

Balance: When shapes, colours and forms have equal importance in a picture.

Brushwork: This is how the artist applies paint to the surface with the brush, e.g. stippled, dots and dabs (Impressionists), bold brush strokes, sweeping brush strokes.

Collage: (a) The art of arranging and sticking materials on another surface to form a composition, e.g. cut paper, card, cloth, found objects. (b) A picture made in this way.

Colour: This can be primary (red, yellow, blue) or secondary (green, orange, purple). Colours can be described as warm (red, orange), cold (green, blue) or earthy (browns and yellow ochres).

Composition: The arrangement of objects within the picture space of a painting or drawing. It may be balanced, dynamic, carefully organised, complicated or symmetrical.

Contemporary: Artists or artwork relating to the present day.

Focal point: The main point of interest in a drawing or painting.

Form: The three-dimensional nature of an object created with light and shade. In sculpture, form refers to the three-dimensional shape of the object.

Line: This is a mark that defines the outline of an object or, when used randomly, creates the impression of an object, e.g. trees. It may also be used to direct the viewer through a painting, e.g. the rhythm of lines in a landscape.

Pattern: The decorative area of a surface: organised shapes and lines. This may be seen in natural patterns or man-made patterns. They are mostly repetitive.

Perspective: The art of creating the illusion of space and depth in a picture, e.g. parallel lines converge on a vanishing point with objects appearing smaller in the distance. Aerial perspective refers to the colours and tones appearing to get lighter as they recede into the distance.

Shape: This element refers to the outline of an object. It may be a natural shape, man-made shape or geometric shape.

Space: This refers to the space within the picture from the foreground to the background. Artists use space to create the illusion of depth and distance with objects appearing larger in the foreground and smaller in the distance.

Style: Characteristics of a time in history or an artist's individual approach to their work.

Technique: The method used by the artist to create their work. How they use media to create artwork, e.g. mixed media, printmaking, etc. Techniques can vary from unrefined to highly detailed.

Texture: This is the surface of an object. It describes the degree of roughness or smoothness. The surface may be soft, hard, uneven, jaggy, furry, shiny or smooth.

Tone: This describes the degree of light or dark in a drawing or painting.

6 Glossary of design terms

Aesthetics: How something appears to the viewer. Its general appearance in relation to beauty. How pleasing to the eye is the design? What makes it attractive? Is it colour, shape, texture, form, pattern, choice of material or something else?

Cost: This refers to how much the design would cost to make. Are the materials intrinsically valuable? Has there been a lot of time spent making it? Who is the target market? Is it unique or one of many? What is the price to buy it? How much profit will the designer make?

Ergonomics: This considers the proportions and shape of the human body. How has this design been made to work with the human body? Is it comfortable, does it fit, is it too heavy or light, how many people are supposed to use it?

Form: This refers to the three-dimensional nature of a design. In design, this also includes size, proportion and overall appearance. The phrase *form follows function* means the look of the design is due to the way it does its job.

Function: This refers to the job that the design does. Every design has a function. How well does the design do its job? Is it efficient in performing its function? Is it fit for its purpose?

Manufacture: This refers to the way in which the design was made. Has the design been made by machine in a factory or by hand? Does it require skill and craftsmanship to make? Have expensive or cheap materials been used? Are they fragile or robust? How are the materials made? Is it built to last a long time? Is it disposable or recyclable?

Materials: In design, the materials used play an important role in the success of the design. Why did the designer choose these materials? What are the qualities of the materials? Are they cheap, expensive, plentiful, rare, lightweight, heavy, man-made, natural, hard-wearing, fragile, soft or easy to work with? Designers will have considered all these factors and more when choosing their materials.

Target market: This term refers to the specific group of people the design is made for. Who has this been designed for? Is it for the wealthy or the poor, males, females, young, old, babies, individuals or groups, a small number or a very large number of people? Is it designed to improve the quality of their lives?

7 Conclusion

In this book we have looked at four different areas of the visual arts:

- **Portraiture**
- **Figure Composition**
- **Still Life**
- **Natural Environment**

The four areas of design covered were:

- **Graphic Design**
- **Product Design**
- **Jewellery Design**
- **Textile/Fashion Design**

The two areas of the visual arts which we did not cover in this book are **Built Environment** and **Fantasy and Imagination**. We also did not include two areas of design studies, **Interior Design** and **Environmental/Architectural Design**.

These areas should be approached and dealt with in exactly the same way as the others mentioned in this book.

The Practical Folio for Intermediate 2 **and** Higher is worth 160 marks in total, i.e. 80 marks for Expressive and 80 marks for Design, and it is of course important that you do well in this area. It is also very important, however, to put the same amount of effort into the written exam.

The written paper for Intermediate 2 is worth 40 marks.

The written paper for Higher is worth 60 marks.

These marks could make all the difference between a pass or a fail or in the grade of your pass.

The whole Intermediate 2 course (practical folio + written paper) is worth 200 marks.

The whole Higher course (practical folio + written paper) is worth 220 marks.

Practice and good preparation are very important before sitting this exam, so organise your study time and develop your study skills. This will give you confidence and will result in boosting your grade!

After looking through this book, talking with your teacher and looking at past papers you should now be ready to sit your exam. You don't need luck, you just need good preparation! You must study and prepare. During the exam try to stay calm, work at quite a quick pace and keep an eye on the clock – timing is very important.

Remember, the written Art and Design Exam is worth enough marks to boost your grade from a FAIL to a PASS or a B to an A!

Good luck and do your best.

Acknowledgements

We would like to thank the Scottish Qualification Authority for permission to reproduce past exam questions.

Leckie and Leckie is grateful to the copyright holders, as credited, for permission to use images of their works of art. Page numbers are followed, where necessary, by t (top), b (bottom), m (middle), l (left) or r (right).

© DACS, London 2011/RMN/Collection Centre Pomidou, Paris/Jean-Claude Planchet: page 19; Richard Hamilton. All Rights Reserved, DACS 2011/Digital image, The Museum of Modern Art, New York/Scala, Florence: page 23; The Cleveland Museum of Art. Gift of the Hanna Fund © Succession Picasso/DACS, London 2011: page 27; Toledo Museum of Art (Toledo, Ohio), purchased with funds from the Libbey Endowment, gift of Edward Drummond Libbey/ Digital image, Photography Incorporated, Toledo: page 28; © bpk/Hamburger Kunsthalle/Elke Walford: page 32l; © Succession Picasso/DACS, London 2011; The State Hermitage Museum, St. Petersburg © Succession Picasso/DACS, London 2011/Digital image, The State Hermitage Museum/Digital image, Vladimir Terebenin, Leonard Kheifets, Yuri Molodkovets: page 32r; © ADAGP, Paris and DACS, London 2011/Tate, London 2011: page 34; Asda Stores Ltd: page 41; © 1967 Neon Rose, www.victormuscoso.com: page 45l; © 2011 Morgan Art Foundation Ltd/Artists Rights Society (ARS), New York, DACS, London/Digital image, The Museum of Modern Art/Scala, Florence: page 45l; © Getty Images: pages 46 and 79; © 2011. Digital image, The Museum of Modern Art, New York/ Scala, Florence: page 51l; © 2011. Digital image, the Metropolitan Museum of Art/Art Resource/Scala, Florence: page 51r; Boucheron: page 52; © Bishin Jumonji and Zandra Rhodes: page 57; William McTaggart, The Storm, National Gallery of Scotland: page 62; © 2011. Digital image, Neue Gallery, New York/Art Resource/ Scala, Florence: page 67; Gift of Mr and Mrs Richard Diebenkorn,in honour of the 50th anniversary of the National gallery of Art, digital image courtesy of the National Gallery of Art: page 67 © Christo & Jeanne-Claude/Wolfgang Volz/ Laif/Camera Press London: page 73; Namco: page 75; LEGO UK: page 77; © DACS 2011: page 81.